IMAGES
of America

NEW HAMPSHIRE'S CONNECTICUT LAKES REGION

IMAGES
of America

NEW HAMPSHIRE'S CONNECTICUT LAKES REGION

Donna Jordan

ARCADIA
PUBLISHING

Copyright © 2003 by Donna Jordan
ISBN 978-0-7385-1193-1

Published by Arcadia Publishing
Charleston, South Carolina

Printed in the United States of America

Library of Congress Catalog Card Number: 2003102248

For all general information contact Arcadia Publishing at:
Telephone 843-853-2070
Fax 843-853-0044
E-mail sales@arcadiapublishing.com
For customer service and orders:
Toll-Free 1-888-313-2665

Visit us on the Internet at www.arcadiapublishing.com

One cold, snowy winter's day in January 2003, as I sat at my computer preparing cover photographs for the publisher to choose from for this book, a call came into my home that Bill Lord had just died. Bill was a very close friend and a great man. His passion for all things Pittsburg, New Hampshire, kept him alive into his 90th year. Many times, Bill would stop in and visit with us, to share some fact or piece of history that he thought we ought to know about, or to give us a box filled with books that he had culled from his vast library. They are books that immediately became a part of our own library collection, with special notations inside of where they came from.

It is for Bill Lord, those who came before him, and, hopefully, those who will follow him, that I wish to honor with this book. It is a visual retrospective of the paths they opened that we all follow in life. It is for all the farmers, the lumbermen, the townspeople, from the early 1800s on into the unseeable future. I expected Bill to be alive so that I could give him a copy of this book as a gift, but someone greater than I has seen to it that. Instead, Bill, serve as my guiding angel in creating a lasting record for those who will come into the world after Bill left it.

When he was but a toddler, Bill's handprint was made in the freshly poured cement for the foundation of his parents' new barn. The time was 1914, and Bill was two years old. His tiny handprint from that time serves as a valuable link to the past. While Bill was able to touch his own childhood handprint until his dying day, many of us wish that we, too, could once more touch our own childhood. That is what a book of historic photographs and historic information is meant to do—to touch our childhoods, those of our parents, of our grandparents, and even further back than that. Like Bill's indelible handprint in the cement, this book marks the connection of young and old. It reaches out to those who desire to know a little bit more about a time they themselves could not touch.

For as long as humankind and nature will allow, handprints will remain etched in their original creations and formations, unknowingly meant for those who will follow and satisfying their insatiable need to know more.

CONTENTS

ACKNOWLEDGMENTS

I wish to acknowledge Carolyn Drew and Robert Gray of the Pittsburg Historical Society, who spent a raw, rainy November day in the unheated Pittsburg Historical Society Museum poring over photographs with me, making recommendations, and helping to write notations. The warm cup of coffee in Moriah's Restaurant, just up the road from the museum, warmed our souls even more as, together, we became more excited about this book project.

John T. Amey, born and raised in Pittsburg, has a true appreciation for his hometown and its history. Many of the photographs in this book are from a collection he found stored inside a wooden box in his attic, along with various newspapers and magazines of the time. John's home had been built by Augustus and Sarah Blanchard in the late 1870s, and their interest in preserving their lives through glass negatives lives on thanks to John's interest in preserving them. John's permission to reproduce them in this book is equally appreciated.

The late Katherine Fogg reached out to me with her vast knowledge of Pittsburg history through her daughter, Muriel Dobson. Katherine spent her entire life in Happy Corner, near Day Road, above Pittsburg village, and she was on the board of directors for the Pittsburg Historical Society. Her research of the town's history, which she published in an article in *Outlook* magazine in the winter of 1977, was a valuable resource.

Ed Sanders in Lancaster provided me with an in-depth look at the history of logging via his Web site, www.greatnorthwoods.com, and it is a testament to his appreciation of history that such an article can exist for everyone to access with the 21st-century technology known as the World Wide Web.

I must also acknowledge my staff at *Northern New Hampshire Magazine*, the *Colebrook Chronicle*, and the *Lancaster Herald*, for they were patient when I furrowed my brow and set aside time to focus on the book during work days. They also provided a modicum of support and interest.

And to my husband, Charles, who should be credited with inventing the meaning of the term "history buff," I offer a big thank-you for his support and advice. He has great foresight with regards to anything that can possibly be seen as being of historic significance—I especially appreciated his old newspaper collection. Our son, Tommy, deserves recognition here as well. Tommy became a teenager this year and has been with us through the entire life of our publishing business. He has been alongside us as we witnessed fast-spreading fires demolish historic districts, barns, and homesteads. He has also witnessed the preservation and restoration of 200-year-old properties. Tommy is fortunate to have had this experience, and he will hopefully carry it into his adult years as he develops a respect and appreciation for the security, comfort, and understanding that the past can offer.

INTRODUCTION

Welcome to Pittsburg, the land of the Indian Stream Republic, Halls Stream, Perry Stream, the headwaters of the Connecticut River, the last town in the state of New Hampshire before you cross into Canada. Pittsburg is also home of Garland Falls, Moose Falls, Hells Gate Falls, and Little Hells Gate Falls; First, Second, and Third Connecticut Lakes; and Back Lake, the man-made Lake Francis, Quimby Mountain, and Magalloway Mountain. Pittsburg is not as small a town as most would think. In fact, it is the largest township in the United States, covering almost 300 square miles. With all of these waters to ply and acres of woods to roam, it is no wonder so many come to Pittsburg for fishing, hunting, canoeing, hiking, and overnight camping.

It was the Treaty of Paris in 1783 that defined the northwestern boundary of New Hampshire as "the northwesternmost headwater of the Connecticut River." Nearly a dozen families lived in the town at that time, including Native Americans. By 1814, at the time of the Treaty of Ghent, disagreements ensued between Canada and the United States over that boundary line. The region became home to deserters, forgers, smugglers, and fugitives. The town's inhabitants, meanwhile, wanted their own "country" and, in response to this boundary dispute between New Hampshire and Canada, declared their homeland to be the Republic of Indian Stream. During a meeting in a schoolhouse on June 11, 1832, they established their own government and adopted their own constitution, bill of rights, and legislative and judicial systems. Luther Parker was elected president of the republic, and Reuben Sawyer was elected sheriff. Nearly all the important branches of government were formed, including an army and a supreme court.

It is said that Sheriff Sawyer kept his prisoners under a 700-pound potash kettle, propped up on one side by a stone for air.

The town, incorporated as Pittsburg in 1840, included the Republic of Indian Stream. In 1842, the Webster-Asburton Treaty finalized the boundary line, and both countries agreed that the land, now formerly known as the Republic of Indian Stream, was in the state of New Hampshire.

The town hosts the state of New Hampshire's only border crossing, opened in 1939 after Canadian customs built a gravel road (now paved) from Second Connecticut Lake to the Quebec border. Even then, the two countries could not agree on the boundary line, and each set its own boundary markers, with an 18-inch space between the two posts that neither country claims—a virtual no man's land.

Pittsburg is the land of many adventures, but it is also the town with many names. In 1811, this land was called Liberty. In 1812, it was called Prospect. In 1820, two land-speculation companies, Eastman and Bedel, dubbed it King Philips Grant and the Old Beedel Grant. In 1831, it was called Drayton (the name given it by the Canadians). It was during the November 1831 session of the New Hampshire legislature that the town was incorporated as Pittsburg.

History records that Moody Haynes (born on September 22, 1813) was asked to name the town, and he named it after Pittsburgh, Pennsylvania, leaving off the *h*. When the town was incorporated, three grants were included: Hubbard, Webster, and Carlyle (or Carlisle).

Many of the photographs in this book came from the attic of the old Blanchard farmhouse (now belonging to the Amey family), on Tabor Road. They appear to date from *c.* 1905, which gives rise to the idea that, perhaps, they were taken that particular year because it was Coos County's 100th birthday. There are many stories to be told of Pittsburg through its 160-plus years, and hopefully we have shown some of them through this book.

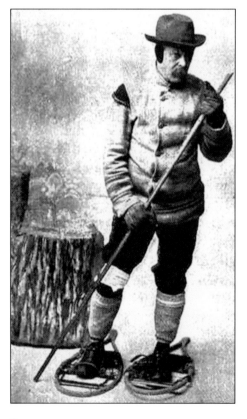

A snowshoe-clad logger poses here.

One

LOGGING

Perhaps the best way to explain the business of logging would be to visit an old-time logging camp of the late 1890s, owned by one of the largest and best-known lumber companies, the Connecticut River Lumber Company. The company was chartered under the laws of the state of Connecticut in 1879 and had 250,000 acres, more or less, of lumber land. The Honorable Asa Smith of Hartford, Connecticut, was the company's first president and a pioneer in the lumber interests of this part of the state. After fours years of service, he resigned and was succeeded by George Van Dyke of Lancaster. An article on this camp was published in the February 1896 issue of *Granite Monthly* and was written by Rev. Orrin Robbins Hunt. He camped for 10 successive sessions, during the months of August and September, on the western shore of the Second Connecticut Lake with the men of the company. He ultimately "pulled the latch-string," he wrote of Samuel Watts, the business manager and treasurer of the company, for winter quarters in one of the logging camps. Hunt noted that 10 years earlier, Watts had taken him on a buckboard into the woods to see the men at work, when Watts was a hostler for the company.

When he arrived at the camp, Hunt was introduced to the "boss," Clarence Robey, and to the cook and cookee. "Boys," said Watts, "I have brought this fellow in to live with you this winter and keep you straight. Feed him well, and let him do as he pleases, and you will have no trouble." The cookee then offered Hunt the use of his bunk to sleep in while cookee proceeded to wrap himself in his blanket and lie on the floor.

"The first healthy omen in the study of lumber works," wrote Hunt, "is the construction of the dams and camps. At the First and Second lakes, and on the East inlet, two miles above the Second lake, are located these dams. The dam on the inlet is thirteen miles from civilization, and among the many obstacles in constructing it was quicksand. This necessitated the use of a pile-driver, and, notwithstanding the fact that it was fifty-six miles to the nearest railway station, a team of good horses was sent down to North Stratford, and in five days was to the lake again, bringing the necessary machine.

"Another difficulty then confronted the workmen,—viz., the crossing of the lake. To do this, two rafts of logs were built to carry the piledriver and another to carry the horses and the provisions for the horses and crew. For the propelling power for these rafts they had eight sturdy Frenchmen in a bateau. With Mr. Van Dyke steering, they reached the opposite side of the lake in about two hours, a distance of one and a half miles."

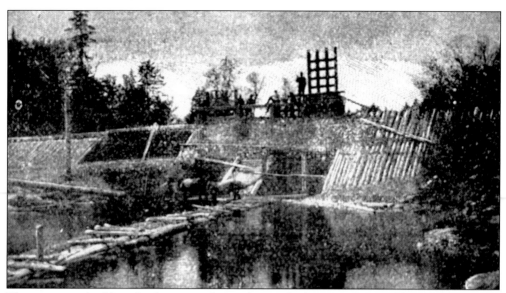

The time spent building the dams varied according to the location. Pictured here is the partially completed dam at the foot of the Second Lake. The photograph shows something of the workmanlike manner in which the dam was built. The Second Lake is about three miles long and two miles wide. By means of this dam, the water level could be raised 13 feet, thus covering a much larger area than the undammed level.

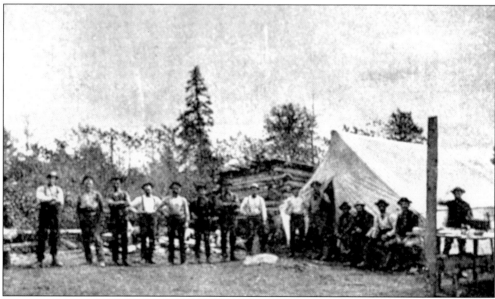

This winter camp could be found by crossing Second Lake to the east shore and going up about three miles. Camps like this were usually located beside a good spring or stream of water and were built as one-story log cabin with two rooms. One measuring 20 by 30 feet was for the workmen and the other, at 18 by 20 feet, was for the cook and a dining room. The camps used to be covered with splits, the first covering being laid flat side up and the second flat side down, covering the joints. The floors were made of small trees hewn on the top side, but eventually both the floor and the roof were made of boards, with two thicknesses of tar paper on the roof.

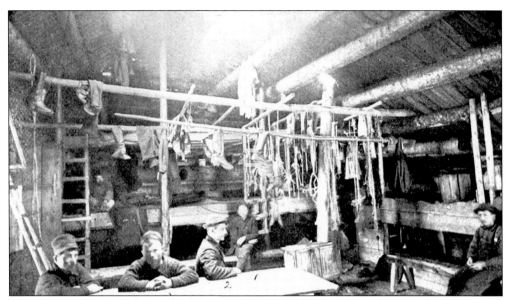

This picture of the inside of a lumber camp shows the bunks where the men slept, the stove over which they dried their clothing, and the room where they sat and smoked. There are four nationalities represented in this group—American, Italian, Irish, and French. The fellow at the right was the cook's woodchopper. He told Rev. Orrin Robbins Hunt, "I no want my picter tooken," but he is in the picture just the same. In fact, they are all in the picture, inside the camp, because of "la grippe." The camps were very warm and comfortable and, under the supervision of the cook, were kept clean and orderly. Lights out was at 9:00 p.m., with all men in their beds. At first, the beds were made of fir boughs and straw, covered by a long, heavy spread, held in place by means of rings and pins on each end. Later, improvements were made even in lumber camps, as the men had berths but furnished their own blankets.

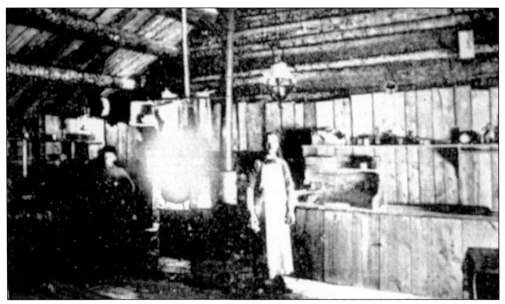

This photograph shows cook Archie Pomelo.

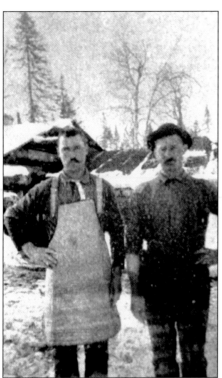

Cook Archie Pomelo and cookee Ed Clever are shown here. The cook you would know by his long apron, but, according to Rev. Orrin Robbins Hunt, to know Clever you had to camp with him. "He rises at 4 o'clock in the morning, builds the fires, and at 4:30 calls the cook, which, by the way, he does loud enough to arouse the entire crew." At 5:00, the cook had his biscuits made, and the breakfast was ready. It consisted of baked beans, hot biscuits, sweetbread, doughnuts, dried apple sauce, molasses, and tea. The other meals were varied each day, although baked beans were always on the table for those who preferred them.

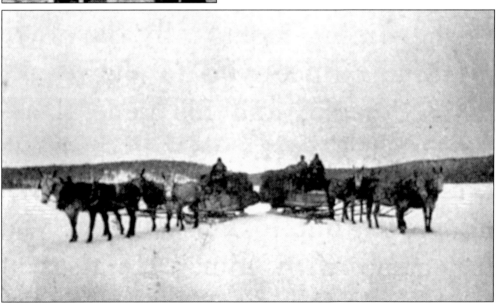

Sunday was a day for general repair and visiting, and in all the camps, the Sunday dinner was pea soup fit for a king. The supplies were brought daily from the store at the First Lake by mule teams, as seen in this picture that shows them at the fork in the road. One team, with Shoppie, is going up to Leighton's camp, two miles up the main inlet, and Tony is going to Hunt's camp. Besides bringing the camp supplies, these tote teams also brought some bits of news from the outside world. At one time, there were 2,000 men cutting spruce around the First, Second, and Third Lakes in Pittsburg.

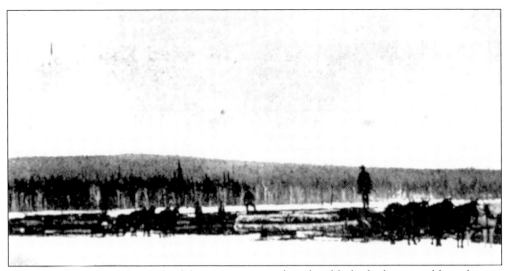

This view shows that the work of the company was done by able-bodied men and large horses. In fact, everything they had to do required power, and a lazy man, or a weak horse or mule, would find no place with this company.

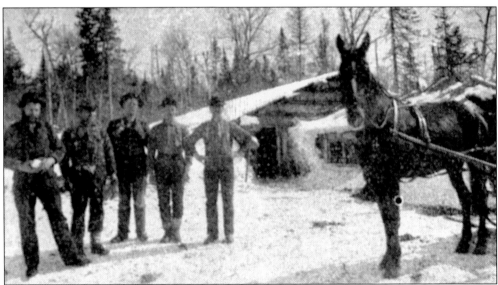

In this view, the man holding the snowball is the blacksmith. He was known to come into camp with a lot of shoes already made. He would shoe all night and, after a little sleep, go to another camp the next morning. He would repeat this operation until he had made the rounds of all the camps. The work was done at night while the crews slept so the horses would be ready when the camp awoke.

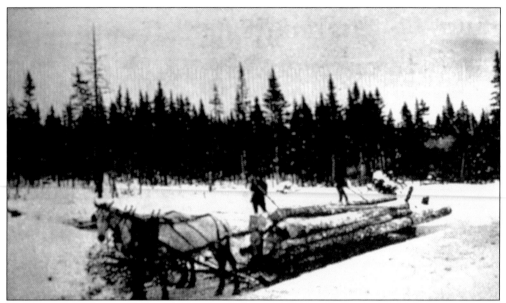

In this camp, there were teamsters, road men, landing men, choppers, swampers, and yarders. The choppers felled the trees, the swampers cleared a path to them, and the yarders dragged the logs to the yard, where the teamsters loaded them. The two-horse team, as seen in this picture, represented a team at the yard loading for the landing.

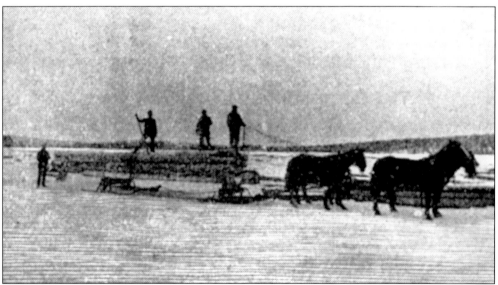

Most of the teams were composed of four horses and made three trips daily from the yard to the landing at the lake, where the logs were drawn out upon the ice and unloaded. The men on the load beside the driver in this picture are landing men, whose duty calls to assist the driver to unload, put the company's mark on every log, and keep count of the same to compare with the number of logs returned by the sealer (seen standing at the rear of the load). Each teamster cared for his horses and assisted in loading and unloading.

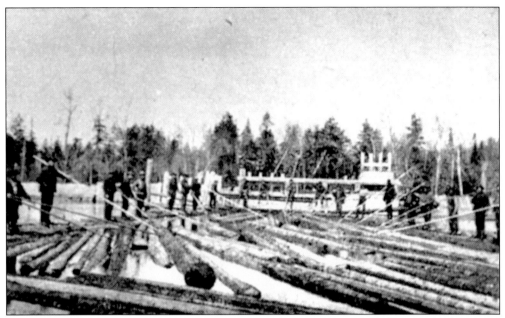

This picture of the dam on Second Lake is a good representation of the way the logs were driven through the gateway into the lake and river below. They averaged one per second going through the gateway.

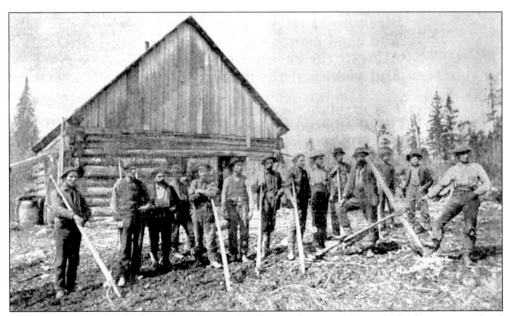

River drivers pose with their cant dogs and other implements. As a whole, logging was hard work, and the men, cut off from any society except that of each other, presented a rough exterior. They told tales of daring adventures as choppers or river drivers.

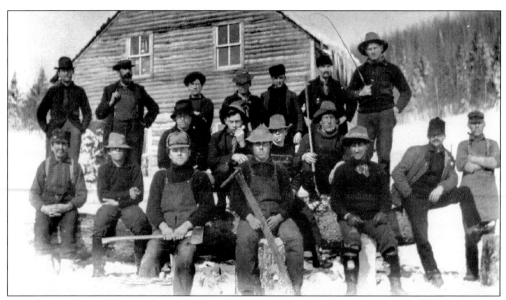

This photograph of a woodcutting crew was taken at what was once called Bowen Pond (now Harris Pond). From left to right are the following: (front row) ? Terrill, Ned Towle, Harry Gray, unidentified, Dan Heath, Frank Smart, and Charles Lord; (middle row) unidentified, Claude Hibbard, unidentified, and ? Day; (back row) Luke Towle, Joe Washburn, George Hilliard, unidentified, Cyrus Blodgett, ? Keach, and Perley R. Schoff.

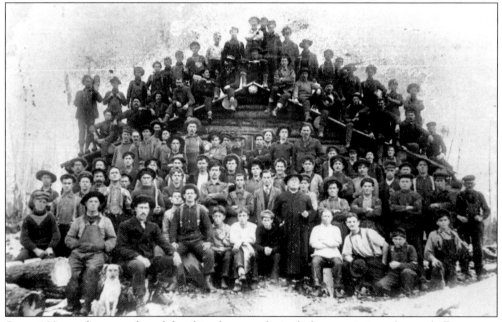

Some 100 woodsmen gathered for this photograph, including a minister (center). From men like these came such homeopathic remedies as a French hotcrop, composed of black pepper, anodyne liniment, and a pint of boiling water, well sweetened with molasses, taken as hot as they could drink it. For a cut or bruise, when a fresh "chaw of terbaccer" did not give relief, they would "snake it out," as they would say.

Two

HOME LIFE

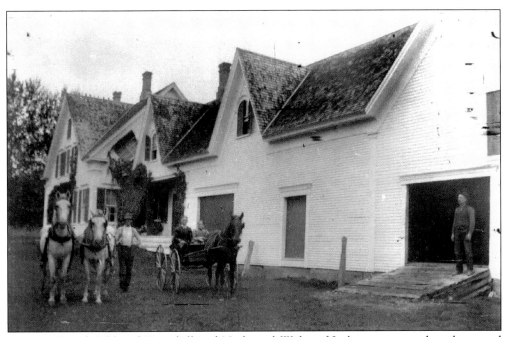

In 1789, David Gibbs of Haverhill and Nathaniel Wales of Lisbon came north to hunt and prospect in and around what is now Pittsburg. Gibbs and Wales became interested in the rich lands and returned the next year with friends to begin a settlement. The severity of the winter, however, caused them to postpone establishing the settlement, and they returned in 1796. By 1820, 40 families lived in the region and included such familiar North Country names as Haynes (or Haines), Hall, Blanchard, Tabor, Bedel (or Bedell), Tyler, Currier, Sawyer, Danforth, French, Baldwin, Huggins, Johnson, and Washburn. Some of the later families included Covill, Day, Scott, Farnsworth, Schoppe, Schoffe, Young, and Abbott.

In this photograph, we see the original James Walt Baldwin homestead, which, even today, sits among the rural landscape. Indian Stream meanders through this land, and on either side were broad fields, considered to be "of the finest intervale and under the highest state of cultivation." The Indian Stream bottomland, c. 1905, was two miles long and a mile or more wide, on which were located several fine farms with "ample, modern buildings, indicating the highest state of prosperity."

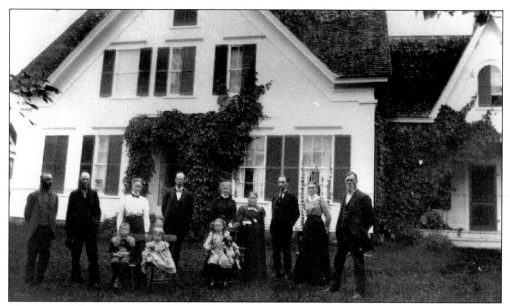

The front of the James Walt Baldwin homestead is pictured in the early 1900s. The farm was considered the model modern farm of its time. James Walt Baldwin lived there practically his whole life, coming here from Baldwin's Mills, Canada, with his parents, Oscar and Ruby, in 1853 (when James was six years old). The family had purchased 300 acres and about 25 tons of hay and pastured several cows during the summer. After Oscar died in 1870, James took over the property and added 200 acres of land on the Pittsburg side and 500 more on the Clarksville side (across the Connecticut River)—a total of 1,000 acres of farmland. All the various produce that was grown on this homestead land, except occasionally a car of potatoes, was reused on the farm so that the soil was constantly growing better and richer. During the summer, when the flow of milk was full, it was taken to a neighboring cheese factory, which did a large amount of its business five months of the year.

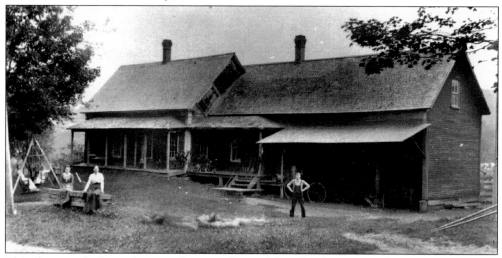

This photograph chronicles an early view of home life in Pittsburg. Note the carriage inside the shed attached to the house, and another along the front of the house (behind the gentleman standing to the right). The clothing the family is wearing appears to date from the late 1800s. Note the nicely homemade lawn swing to the left.

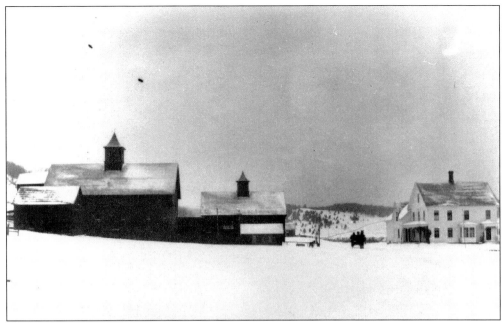

Shown here in winter, this farm sits along Tabor Road, in the Indian Stream territory. Cyrus Farnham lived here in 1853, and it was later known as the Blanchard farm.

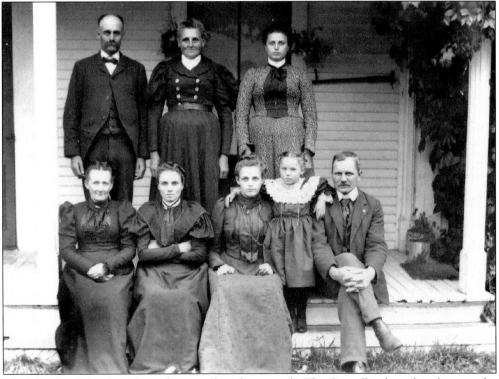

The Blanchard family is shown here on their front porch. The Cyrus Farnham farm became the home of Augustus and Sarah (Baldwin) Blanchard. Augustus was the son of Timothy Blanchard. Sarah was the daughter of Justis W. Baldwin and the sister of Frank Baldwin.

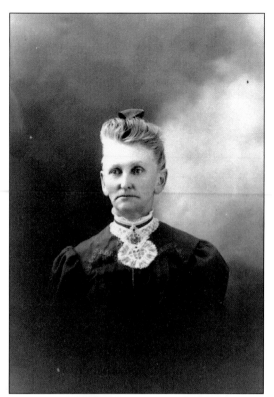

Sarah Blanchard, shown in this portrait, had the reputation of running to sweep off the porch when a strange team appeared around the bend.

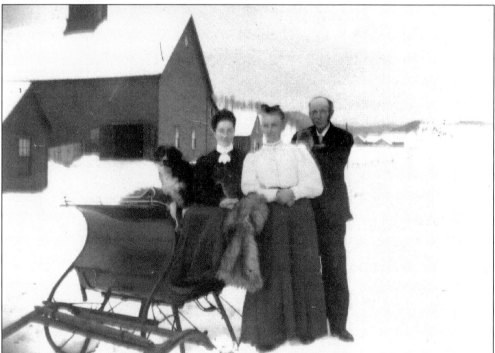

Shown in front of their distinctive barns, Sarah and Augustus Blanchard pose with a sleigh across Tabor Road from the farmhouse.

Rufus and Eugene Day were only too pleased to pose for the traveling photographer. Note the photographer's curtain with its scenic backdrop behind the two boys.

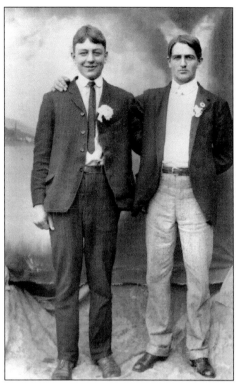

Richard Arthur Tabor was born on January 21, 1847, to Parker and Elizabeth. Richard's twin brother was Richmond, and they had a sister, Sophia, a younger brother, Clarence, and an older brother, Jeremiah. While Richmond went west to Wisconsin, Jeremiah went to Portland, Maine. Richard stayed with the family homestead and, in 1881, married Sarah Coates. They had one son, Parker Wilson Tabor, on July 31, 1884.

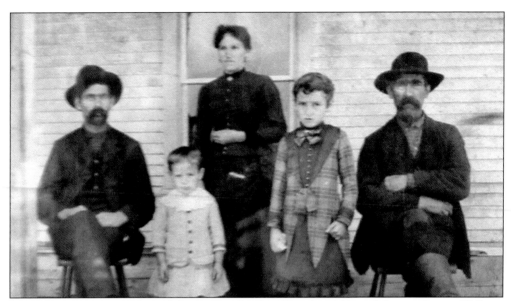

Posing *c.* 1890 are members of the Hawes family of Pittsburg. From left to right are William (1853–1888); George W. (1886–1969); Julia Day Hawes (1853–1951); Melinda, also known as Linnie (1879–1954); and John Thomas (1822–1916).

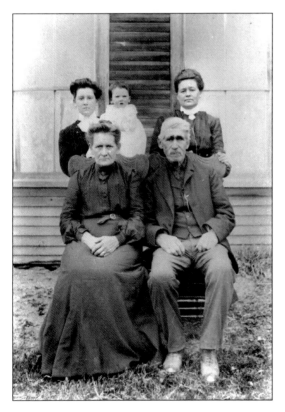

Members of the Hawes and Day families are shown *c.* 1905. From left to right are the following: (front row) Mary Ann (Hawes) Day (who wed Parker Tabor Day) and her father, John T. Hawes (born in England in 1822); (back row) Mary Ann (Johnson) Crawford, who married Almon Crawford; her daughter Elsie Ruth Crawford (who later married Charles Howard); and Almeda (Day) Johnson, who married Oliver Johnson.

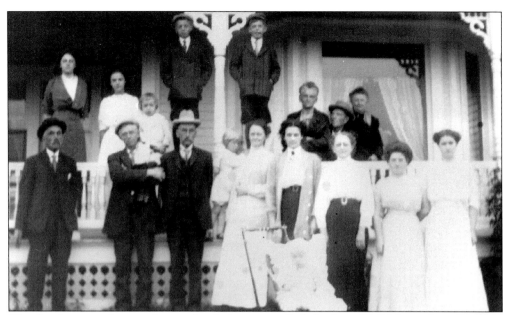

This family is standing at the porch of what was called the Lucy Hall House. Lucy Blodgett married Harry Hall. Before Lucy and Harry lived here, it was owned by George Baldwin. This home sits on the town's main street, across from the Pittsburg School. In later years, Lucy was known to stand just outside her back door and feed about 200 mallard ducks that lived in the open water of the Connecticut River in back of Lucy's house.

Pictured here is the home of Bill Lord, to whom this book is dedicated. It is believed that Bill Lord is the infant in this picture, with his mother, Edith, and father, William, to her right.

Tabor Road, the land where Indian Stream passes through a fertile valley of farmlands, is a bit wider today, though not by much. The line fence can barely be seen as it blends with the fields.

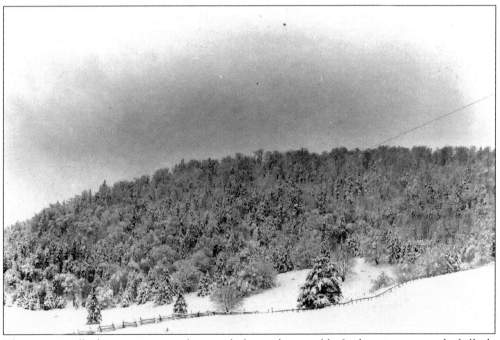

This is practically the same scene as above with the road not visible. In this view, we see the hillside blanketed in winter white and the line fence just barely shows against the white backdrop.

This photograph shows Will and Ada Coates with son Neal. The Coates family lived on the River Road, which no longer exists.

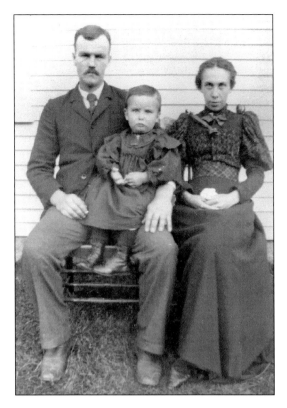

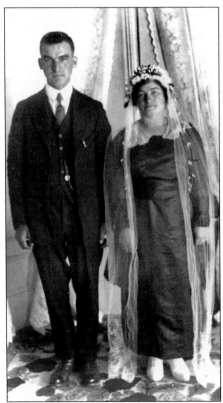

Lottie Young, from the Benjamin Young family of Clarksville, is pictured on her wedding day with her groom, Francis George Rancloes of Pittsburg.

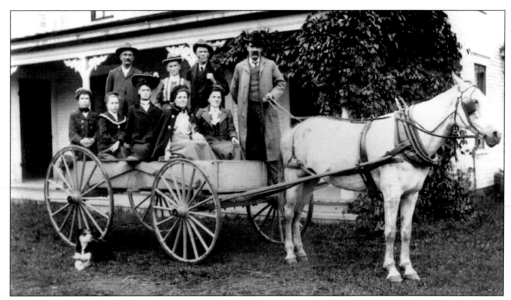

Before there were paved roads, there were paths worn in the dirt, and folks traveled over these paths by horse and carriage. In 1901, many residents brought their carriages to nearby West Stewartstown to the shop of W.J. Flanders to have them repaired and painted. He advertised in the *Frontier Gazette*, "I am prepared to new rim light wheels for $1.25 each. Set new spokes for 10¢ to 14¢ each. A new pair of bent buggy shafts including cross bar for $2.25. If these prices are not low enough I will include a horse with the shafts."

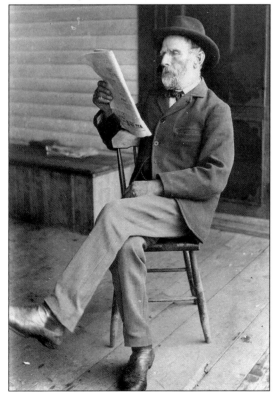

This Pittsburg citizen is most likely reading the *Frontier Gazette*, a weekly newspaper whose Pittsburg column would have included such news as "John Bracket has bought Scott Lord's house. H.A. Blanchard, wife and Jesse also Frank Fuller and George Baldwin started Wednesday for Buffalo." News from Hall Stream would include "Gardner Smith has purchased one half of Ed Hall's farm. The friends of D.S. Keysar will be sorry to know that he is very sick at his daughter's, Mrs. Frank Perry, and the family and his many friends are very anxious about him."

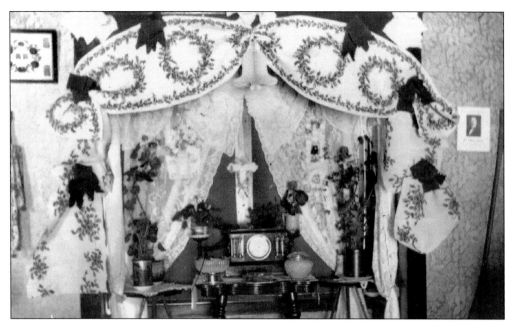

It appears that a funeral is being held in the Blanchard parlor in this photograph. Such events were tended to by Augustus Blanchard.

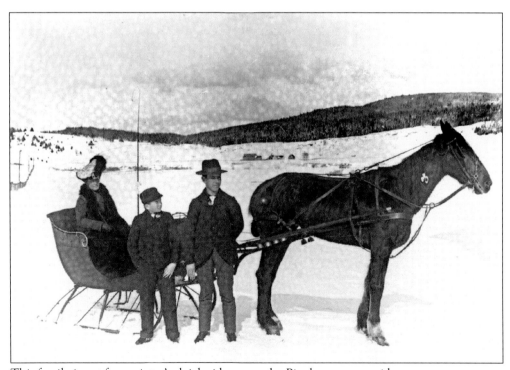

This family is out for a winter's sleigh ride across the Pittsburg countryside.

This wintry scene offers a view of the Indian Stream valley. Around the time that this photograph was taken, Jesse Blanchard had just spent the summer giving two pupils swimming lessons, and the farmers had reported a light haying crop that year.

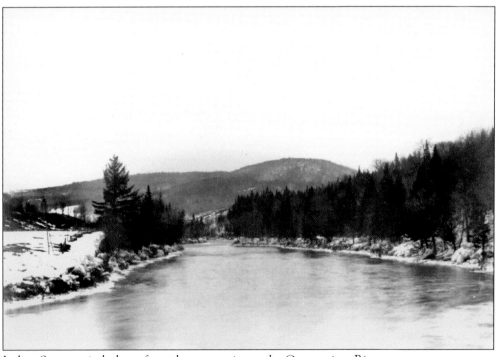

Indian Stream winds down from the mountains to the Connecticut River.

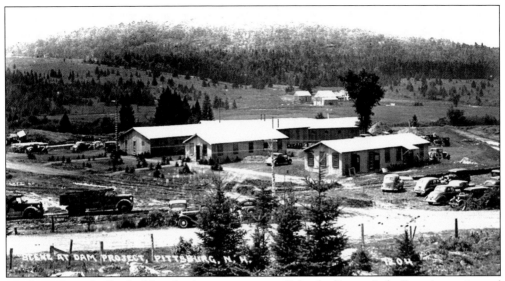

The barracks and office building for the construction of Murphy Dam at Lake Francis are pictured here in the summer of 1938. The roadway at the bottom of the photograph is old Route 3, and the barn buildings at the top of the photograph belonged to Harry and Lucy Hall. It has been suggested that this picture was taken before the big September 1938 hurricane, which blew down many trees and buildings in the area.

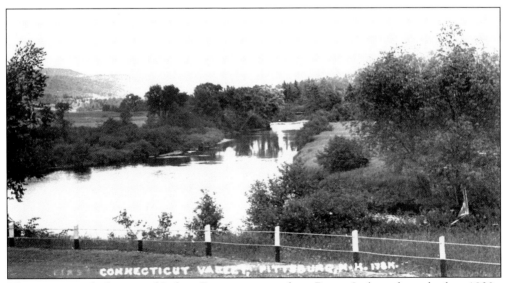

This scenic roadside vista of Indian Stream, as seen from Route 3, dates from the late 1930s. Old Route 3 ran close to Indian Stream and made an S turn over to the covered bridge and out onto Tabor Road.

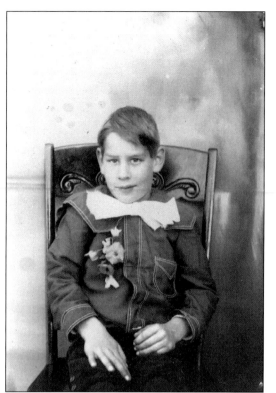

Victor Cairns Scott, the son of William Edward and Anna Hope Scott, was born on July 13, 1897. When he died on December 24, 1959, he was buried in the Pittsburg Hollow Cemetery. The Scott family, Charles and Sarah (Jarvis), came to Pittsburg in 1877 from Canada. They bore four boys and two or three girls and settled on what is known as the Scott Road. At one time, that area of town was known as "Little Heaven," though some suggested it was more like "Little Hell."

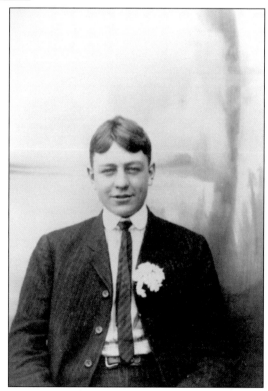

One of the Day boys is shown dressed up for a photographer's visit.

Three

PORTRAITS

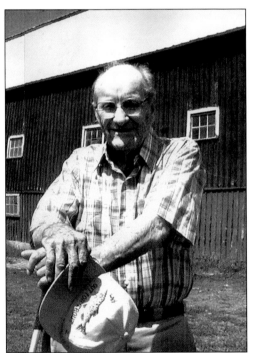 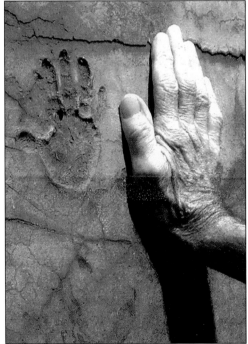

Bill Lord is pictured to the left in 2001 with the family barn on Route 3 south of Pittsburg village. An extraordinary family heirloom is Bill's handprint, which was pressed into the newly poured concrete of the barn's foundation in 1914, when Bill was just two years old. To the right is Bill's hand in 2001 alongside the impression he made in the cement. (Photographs by Charles Jordan.)

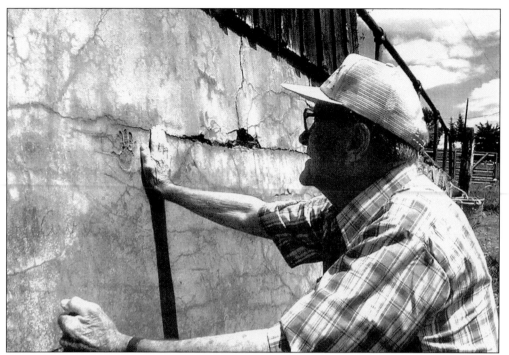

Bill Lord well remembered the day the workmen held him up and placed his little hand into the wet cement. (Photograph by Charles Jordan.)

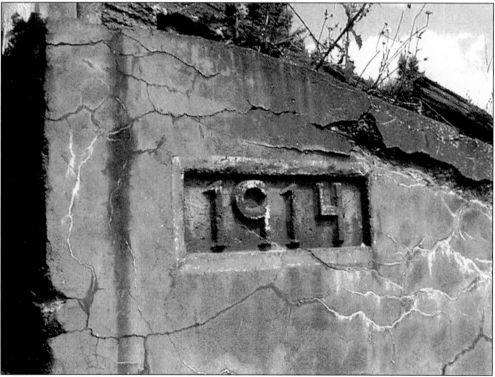

This photograph shows the date that was set in the barn's foundation.

Mary Jane (Jennie) Wheeler Schoff and her husband, Nelson Schoff, are shown with their boys, Guy and John. The Schoff family was of German descent, coming to the United States in 1752. The first Schoff in Pittsburg was seven-year-old Hiram, who was "farmed out" due to the death of his father, who drowned in a logjam on the Connecticut River in 1808. Hiram later married Rebecca Brainerd.

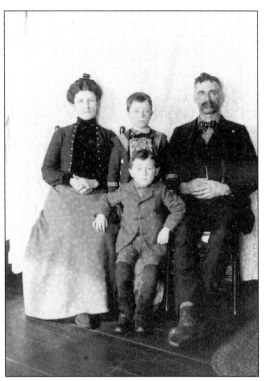

Shown in this photograph are Berry and Afton Hall.

Gilbert and Rachel Scott pose with their firstborn son, Austin.

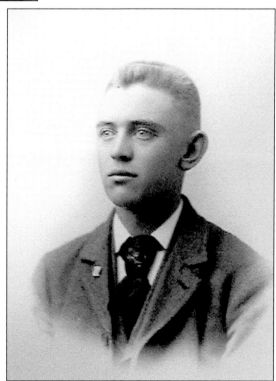

Frank Baldwin, an enterprising young man, started in the mercantile business at the age of 19.

Pictured here is George Baldwin,
Frank Baldwin's uncle.

Shown in this photograph
is Will Judd.

Hattie Schoff is featured here.

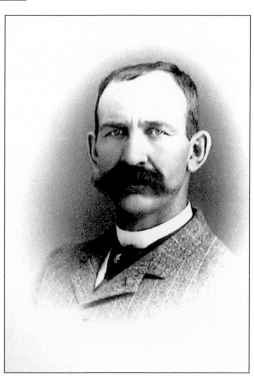

This portrait shows Will Abbott.

Kirt Hawes poses with
his uncle Ed Keach.

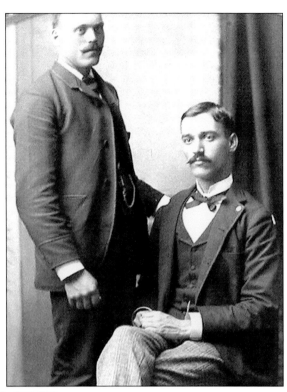

In this photograph, Matilda Crawford is
on the right.

Lottie Smith poses in a chair.

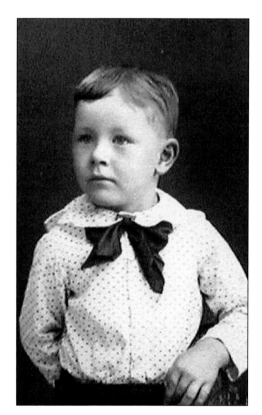

Shown in this photograph is Merton Aldrich, who later became the father of Cecil Aldrich.

George Van Dyke, pictured here, was at the head of the great lumbering industry of Pittsburg. Born in Stanbridge, Vermont, on February 21, 1846, he moved to Hereford, Quebec, with his parents when he was a young boy. George Van Dyke went to work "in the woods" when he was 14 years old. By 1897, he had organized the Connecticut Valley Lumber Company. While viewing a log drive in August 1909, Van Dyke and his chauffeur were killed when their automobile plunged over a 50-foot-high ledge into the Connecticut River near his mill in Turner's Falls, Massachusetts.

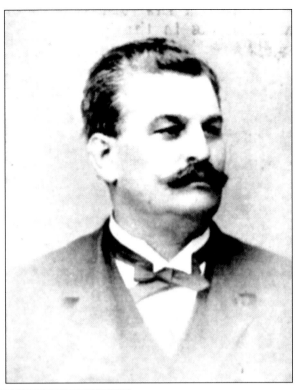

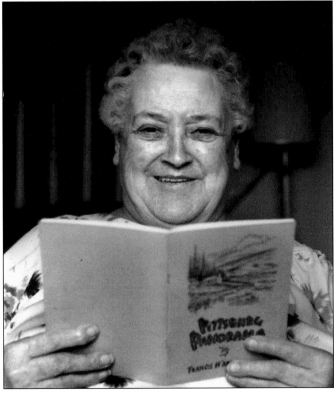

Historian Katherine Fogg, one of the founders of the Pittsburg Historical Society, poses with the 1960 booklet *Pittsburg Panorama* in 1990. (Photograph by Arlene Allin, Northern New Hampshire Magazine.)

Dorothy Amey collected the birth dates and signatures from every person she ever met in her 70 years of life. She inherited the collection in 1959 from her father's sister Lora. (Photograph courtesy Northern New Hampshire Magazine.)

The collection of signatures and birth dates began with Dorothy Amey's paternal grandmother, Mertie Sprague, in 1911, when Mertie was given a copy of *Daily Bread: A Birthday Textbook* as a Christmas gift from her sister-in-law Abbie. It resembled a memo book with dates, Bible verses, and plenty of blank pages. (Photograph courtesy Northern New Hampshire Magazine.)

The handwritten guest book entries (various signatures, dates, and names):

Cherilyn Crawford
Edouard Dupuis
August 27
1904 Alfred C. Fairfield
1931 Clifton Clogston Jr.
1965 Michael G. Washburn
1933 Burnham A. Judd
1924 Jessie Parsons Caldwell
Edith (Winnie) Hodge
Shirley Goodwin
Mary Cummings 1949
Theda Mace 1949 I.F.Y.E. '63
Dorothy Person 1930
August 20
1918 Harriet Rice 1966
1912 Emily D. Haynes
Ed Yennington 1926
1929 Wayne Husband
Germaine Bonneau Aug. 14 1922
Shirley P. Linwood

July 10
Gordon Ramsay 1934
Harold A. Smith 1928
Elsie B. Hall
Dana E. Small 1946
Amy J. Blodgett 1894
July 11
Betty Drewroot Lavigne
Melvyn A. Jadworth
Jim Lambert
Conrad L. Hook 7-11-19
Jean Paul Bonneau 7/11/21
July 12
Mabel B. Savage 1918
William E. Dickinson
Barbara V. Haynes
Kim Nilsen (Coos Cty. Democrat)
Pam Jordan
Dennis Masters

Dorothy Amey's son John once said that his mother loved going to conventions with her book because she saw it as a great opportunity to collect new names and birth dates. John said the family figured that there were about 1,800 names in the two books that three generations had filled. (Photograph courtesy Northern New Hampshire Magazine.)

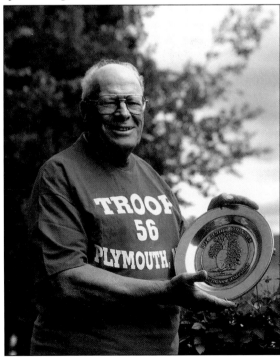

Harold Webster, who lives on First Connecticut Lake in Pittsburg, is seen here holding the commemorative plate given to him by the Rumney Snowdrifters in appreciation of his lending the snowmobile club a hand during his years with the state highway department. The plate is engraved with the Plymouth Common's Boy Scout statue that he posed for as a young Boy Scout. He is wearing a T-shirt given to him by young members of Troop 56 at the rededication of the statue in September 1997. (Photograph courtesy Susan Zizza, Northern New Hampshire Magazine.)

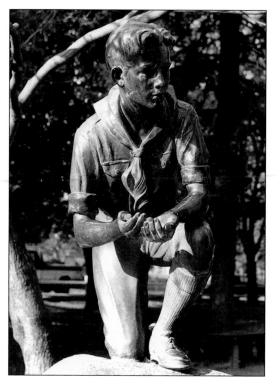

In order to create the illusion of a young Boy Scout dipping his hands into a stream for a drink of water, a pipe was positioned through the right leg and then through the body and arm of the statue. The sculptor of the bronze statue was George H. Borst of Philadelphia, Pennsylvania. Harold's mother, Charlotte, was the chairman of the Plymouth Common refurbishing committee, which was formed to commission the sculpture. For two or three days a week during the summer of 1933, Harold posed for three to five hours at a time, on one knee, arms outstretched and hands cupped. (Photograph by Charles Jordan, Northern New Hampshire Magazine.)

Harold Webster's mother, Charlotte, was a civic-minded individual. Harold describes her as not quite five feet tall, but full of spunk and spirit. (Photograph courtesy Harold Webster.)

Four

BOSTON POST CANE HOLDERS

John Thomas Hawes was Pittsburg's first holder of the Boston Post cane. On September 3, 1909, the cane was presented to the chairman of the Pittsburg Board of Selectmen, George W. Baldwin. He immediately identified John Thomas Hawes as the oldest male in town. Hawes, born in Bussingham, England, sailed to America on the *Captain Brunswick*. He landed in Quebec in 1834, came to the United States in 1841, and moved to Pittsburg in 1863. He was a couple months shy of turning 88 years old when he received the cane, and it is said he highly appreciated the gift. He married Octa Holden of Stewartstown, and they had nine children.

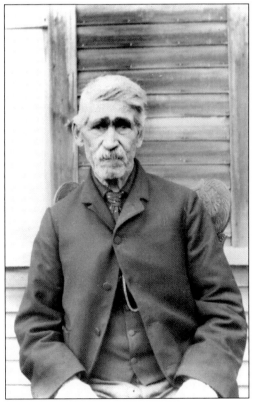

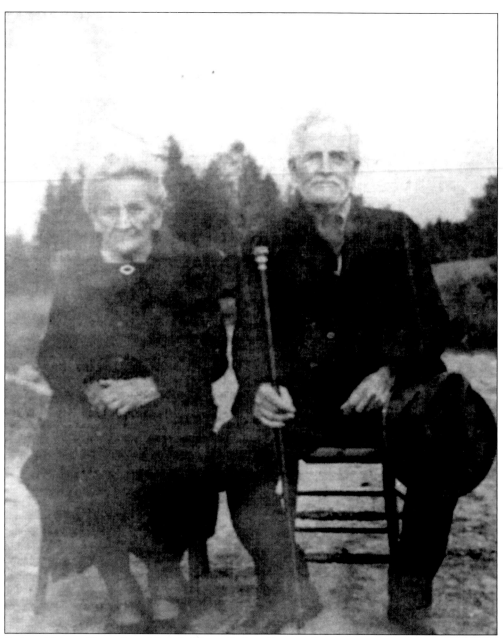

Parker Tabor Day, the third holder of the Boston Post cane, poses with his wife, MaryAnn Hawes Day. Parker held the cane from December 10, 1926, until August 1935. He was born on February 16, 1864, and worked as a farmer and a lumberman. After Day, Henry Scott Lord received the cane, which he retained until November 11, 1943. Lord was born on May 19, 1851, and he had farmed for Richard Tabor before becoming the fire warden at Indian Stream. Peter Mousseau received the cane next and held it until he was 91 in 1946. Mousseau was born on May 31, 1855, and was a blacksmith. Julia Day Covell, Parker Tabor Day's sister, was the first woman in town to hold the cane, and she did so from 1946 until 1951, when she died at the age of 93. Belle Blodgett Parks next received the cane until her passing in July 1957 at the age of 95. Rachel Cairnes was the next holder of the cane until August 1960.

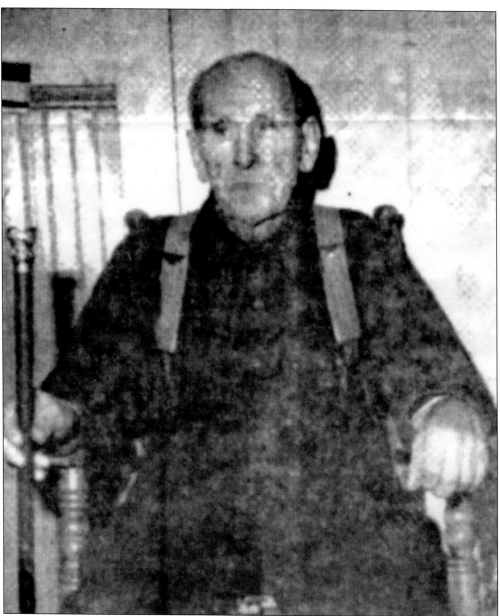

Norman Robie next received the cane in August 1960, when he was 88 years old. At that time, it was reported that he was still doing chores around his daughter's home. Born in Clarksville, Robie had been a resident of Pittsburg for 67 of his 88 years. Robie held the cane until September 12, 1964, at which time it passed to Mary Cairnes Scott until October 1965. William Henry Lord held the cane for only two days before it went to Lucy Blodgett Hall until February 1979. The next five recipients included Matilda Jackson Crawford (until 1985), Yvonne Henrichon Lord (until June 1990), Ann Smith Wilkinson (until April 1995), Glenn French Hilliard (until December 1995), and Iva Day Scott (until November 1996). Iva Day Scott was born in Pittsburg on April 14, 1898, the daughter of Harvey and Martha Shallow Day. The last person to receive the cane in recent times (1998) was Leo Brooks, who has since passed on.

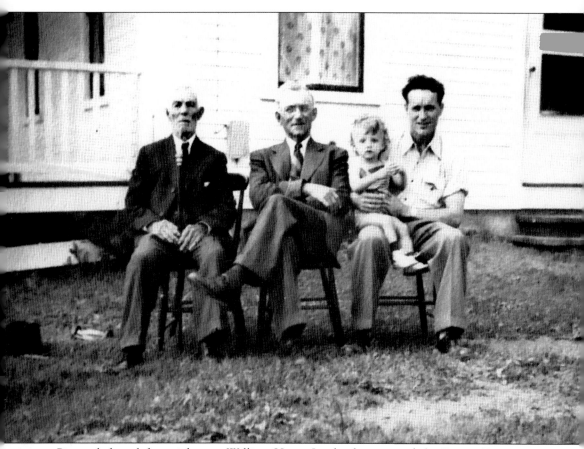

Pictured, from left to right, are William Henry Lord, who received the Boston Post cane in October 1965; his son Will; baby Stephen, Bill's son; and Will's son Bill, who inspired the dedication of this book.

Five

MERCHANTS, INDUSTRY, AND EDUCATION

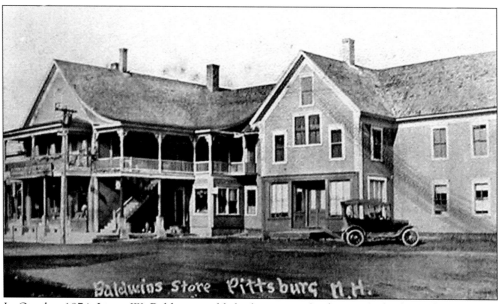

In October 1874, Justus W. Baldwin established a store in his house. As his line of goods grew, Justus built Baldwin's General Store about a mile south of the present location (known today as Moriah's Restaurant). In April 1895, Justus started his 19-year-old son, Frank, in the business with a stock of boots, shoes, notions, patent medicines, jewelry, and more. In 1897, Frank himself enlarged the store so that it covered 6,000 square feet in the town's village district. In 1902, seeing the need for a storehouse near the railroad line in West Stewartstown (where he could unload the heavy merchandise), Frank built not only a storehouse but also a store. In the basement was a 50-horsepower boiler that provided steam heat and power. The power helped operate the Morse and Williams elevator used to move goods between floors, the Robinson patent steel mill in the basement of the store, and the grain elevator that took grain from the rail cars on the side track to the desired bin.

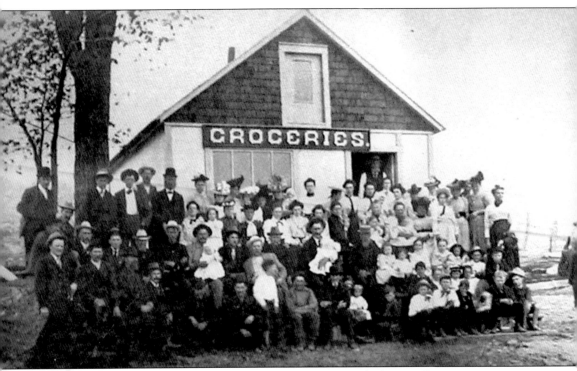

Shown in this photograph is Washburn's General Store in the lower village.

Known to feed deer next to his general store, Frank Baldwin once came across a stray baby deer in Clarksville. The deer, about three days old, was lost from its mother and was near death, so Baldwin brought it home. From then on, the fawn followed Baldwin everywhere he went. Baldwin brought his baby deer with him to the Guides Show for everyone to see.

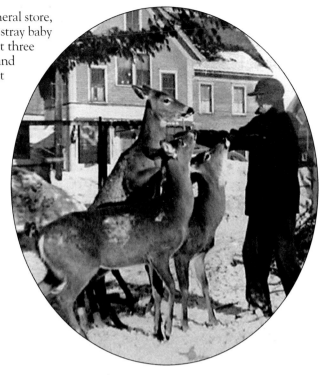

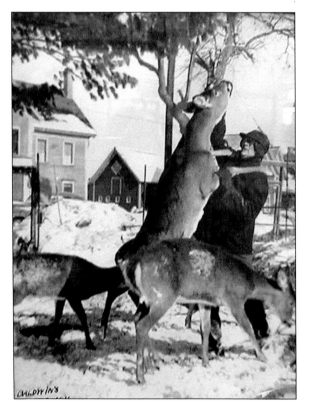

This photograph shows deer being fed at Frank Baldwin's.

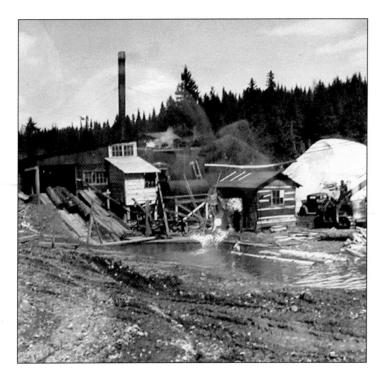

This sawmill, shown c. 1948, replaced the original mill, which burned in November 1947. The mill was located near the spot where Echo Valley Village is today in the town's village.

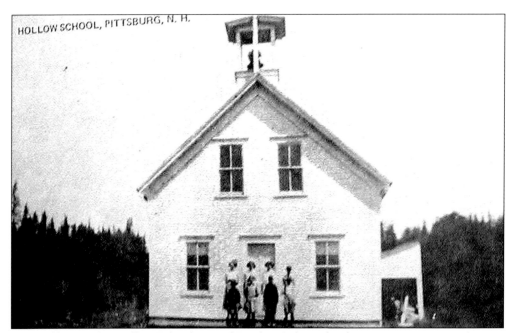

Pictured here is the Hollow School, one of Pittsburg's first schools.

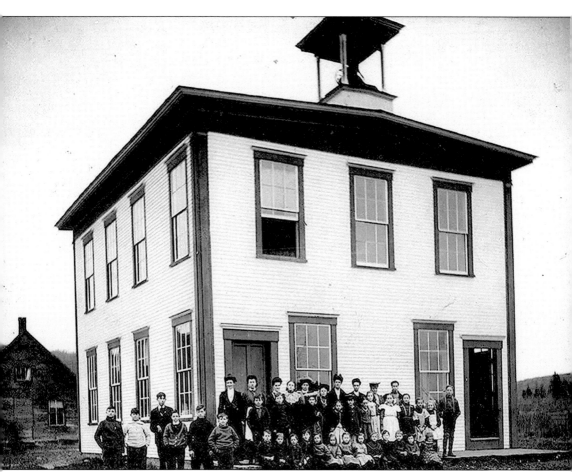

This is the Village School building, which sat on the same lot as the present-day school. The first known school in the republic was established in 1821, when Betsey Rogers taught in a log house on Indian Stream. The first school building was a log structure on Hill Road, with Elisha Abbott serving as the first teacher. A larger school was built in 1828, and it also served as a town hall, courthouse, and sometimes church.

The present Pittsburg School is a brick building constructed between 1912 and 1915, and it housed grades 1 through 12. In 1949, a fire gutted the building, and classes were set up in the church, town hall, and the Grange building, which had once again become a school for a couple of years. A new gym was added to the present building in 1960, as well as a wing to house elementary grades, and the Bremer W. Pond Auditorium and Library.

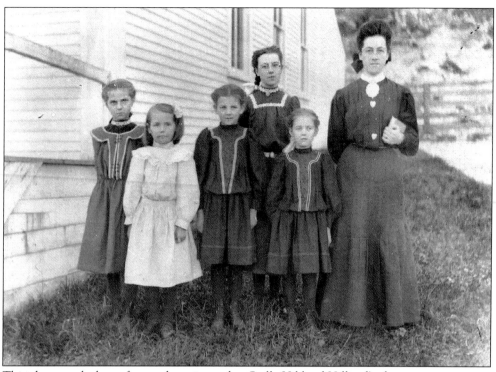

This photograph shows five students in teacher Stella Hibbard Hilliard's class.

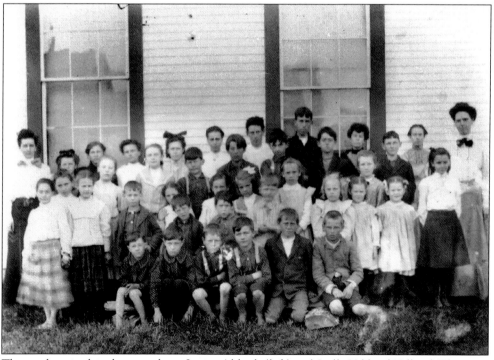

The teachers in this photograph are Janice Aldrich (left) and Stella Hibbard Hilliard. There are quite a number of students in this particular school.

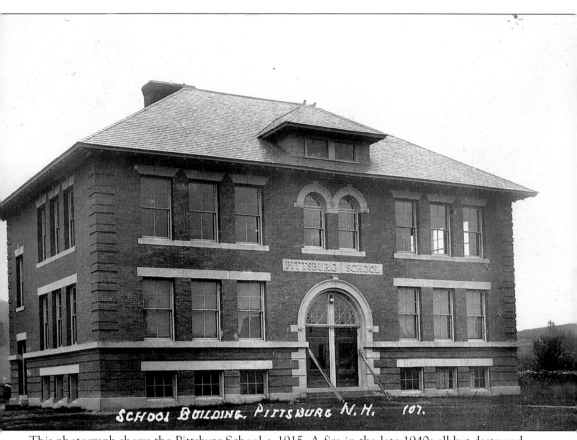

This photograph shows the Pittsburg School c. 1915. A fire in the late 1940s all but destroyed the old school.

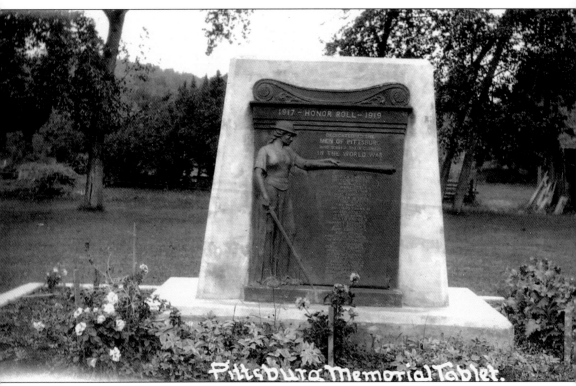

1917 ~ HONOR ROLL ~ 1919

DEDICATED TO THE
MEN OF PITTSBURG
WHO ENABLED THEIR COUNTRY
IN THE WORLD WAR

Pittsburg Memorial Tablet.

This memorial identifies the Pittsburg soldiers who served in World War I.

Six

PLACES TO STAY, THINGS TO DO

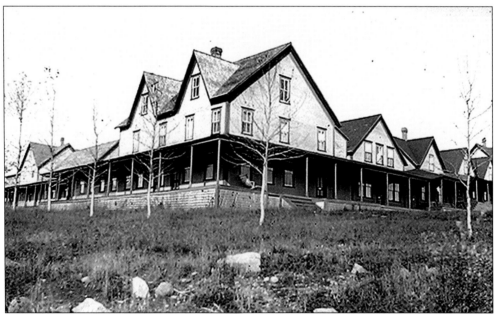

Only a brochure from the early 1900s can truly sing the praises of Pittsburg, the Connecticut Lakes, and why a visitor often escapes city life for this countryside. "In the northeastern part of New Hampshire, close to the Canadian boundary line, nestles the three lakes that form the sources of the Connecticut River: First, Second and Third Lakes. Located in the midst of wilderness, surrounded by unbroken forests and guarded by mountains that rise on every side and down whose slopes leap noisy trout streams, these lakes can hardly be surpassed in natural beauty and in the attractions they offer to the lover of nature who seeks recreation or rest." Pittsburg has been described as a sportsman's paradise by visitors who have made the trip to this far northern town beyond the 45th parallel. In 1914, Metallak Lodge, shown here, was managed by W.M. Buck of nearby Canaan, Vermont. At that time, he spared no expense for the visitors to the lodge and even built a special storage sheds for their shiny new automobiles.

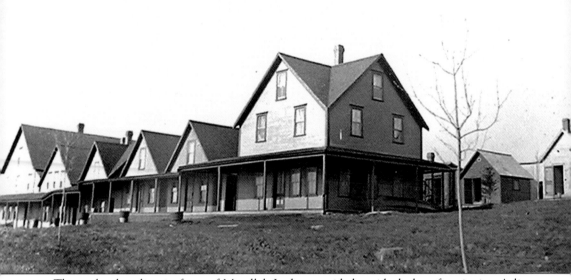

The rocky shoreline in front of Metallak Lodge provided an ideal place for picnics. A livery stable was maintained for guests, and good guides were always available. The local telephone was, at one time, connected with the long-distance telephone and telegraph station at West Stewartstown and to the office of a physician. In the early 1920s, the lodge was purchased by the Connecticut Valley Logging Company and was later sold off as individual camps that were moved to various private lots around the lake.

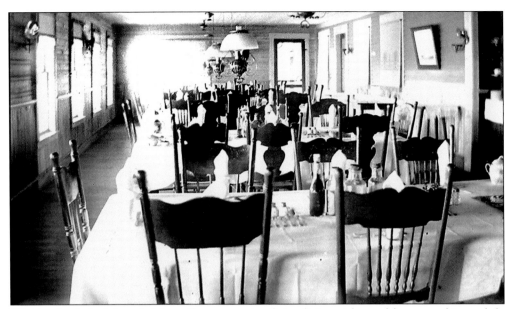

Within the lodge's hospitable walls was an air of simplicity with good home cooking, while outside, there was bracing mountain air and clear spring water. The dining room was large and airy. There was a quiet parlor suitable for reading or writing. A large recreation and music hall offered a space for entertainment and dancing. A farm and garden supplied fresh milk, eggs, and vegetables. Wild strawberries, raspberries, and blueberries were also served.

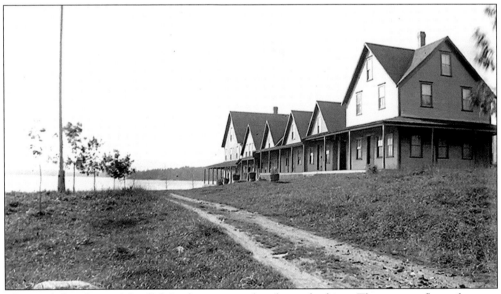

The sandy beaches at Metallak Lodge were perfect for sunbathing. There was a fleet of canoes and rowboats for guests to use on the lake, and a paddle to the head of the lake at sunset or sunrise was usually rewarded with the sightings of deer. A cheerful log on the hearth in the office area was especially popular during evening hours. The lodge consisted of a group of cottages in varying sizes connected by a continuous piazza. Single rooms or entire cottages could be reserved, but since the number of guests was limited to 60, reservations were accepted on a first-come, first-served basis.

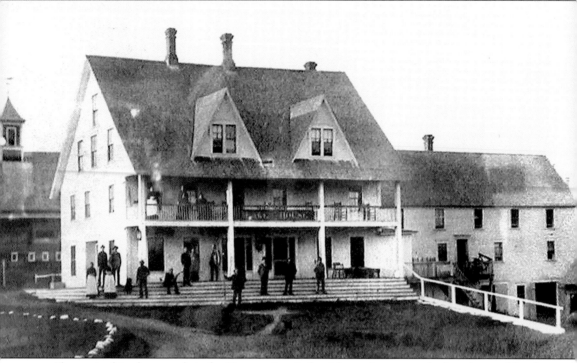

Shown in this photograph is the Connecticut Lakes House, known as the hotel owned by the Connecticut River Lumber Company. It was built in 1860 by Fernando C. Jacobs of Canaan, Vermont, and West Stewartstown, New Hampshire. Asa Smith managed the three-story gabled depot camp when it was owned by the Connecticut River Lumber Company. The Connecticut Lakes House was torn down in 1930 to make way for the new dam.

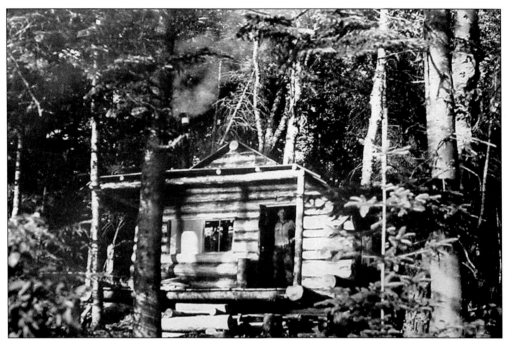

This photograph shows a log cabin at Scott's Bog. Other names of camps that have appeared include John's Lodge on First Connecticut Lake, Chapple's Camps, Reynolds's Camps, Varney's Log Camps, and Suits-Us-Camps.

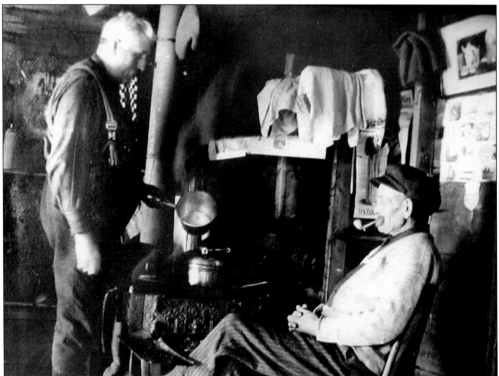

Sitting in a chair at this camp is Bert Aldrich. The Aldrich family first settled in Pittsburg in 1824.

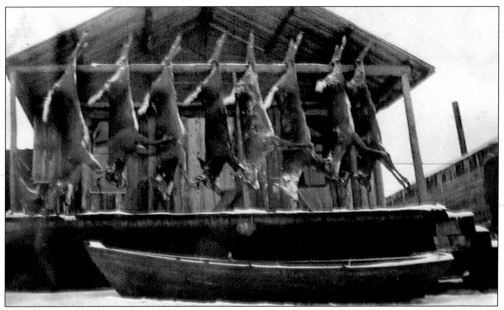

Deer hunting was a big sport in the Pittsburg area. In this photograph of long ago, deer are hung along the side of a cabin. The hunters probably used one of the local guides.

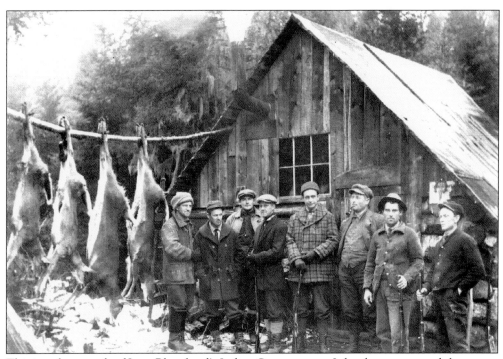

This is a photograph of Jesse Blanchard's Indian Stream camp. It has been suggested these men were from Benson's Animal Farm, formerly of Hudson, New Hampshire. The man on the far right is Jesse, and next to him is Francis George Rancloes.

GUIDES'

SPORT SHOW

Sponsored by New Hampshire Guide's Association

CAMP OTTER
Pittsburg, N. H.

- - *First Connecticut Lake* - -

Fri., Sat., Sun., AUG. 11-12-13 1939

Program to Include:

Canoe Events Fly Casting Kettle Boiling
Motor Boat Racing Log Rolling
Wood Chopping Knife Throwing
Exhibition Trick Shooting by BILLY HILL, Remington Arms Co.
Competitive Shooting Between
Maine State Wardens - New Hampshire State Wardens
New Hampshire State Police
Airplane Stunt Flying!
Turkey Shoot Trap Shooting And Other Events
New Bleachers have been built for your convenience
GATE PRIZES WILL BE AWARDED DAILY
Admission 40c; Children under 12 15c

FRIDAY NIGHT & SATURDAY NIGHT
Dance - Pittsburg Town Hall
Music by Doc Converse and his Hill Billy Band
Admission 40c

This poster is from the 1939 Guides' Sport Show, held at Camp Otter and sponsored by the New Hampshire Guides Association.

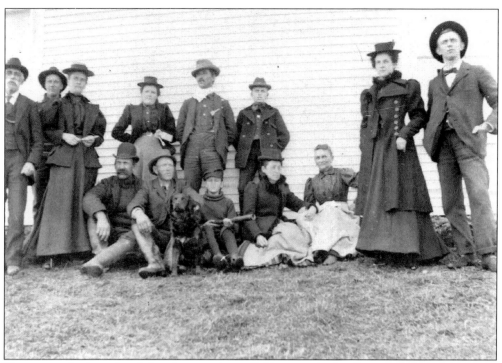

The man at the far right of this photograph is a Baldwin, undoubtedly responsible for gathering these people together for an outing.

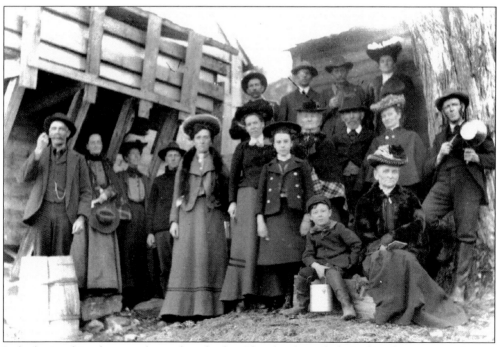

It looks in this photograph as though the Blanchards and their friends are preparing to tap maple trees.

Toward the end of maple syrup season, grand sugaring-off parties are held. This couple dressed up comically for the occasion.

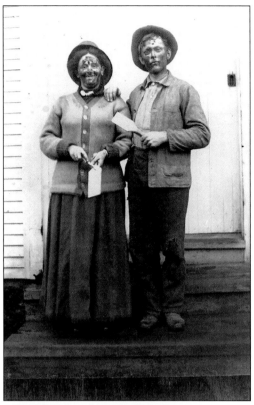

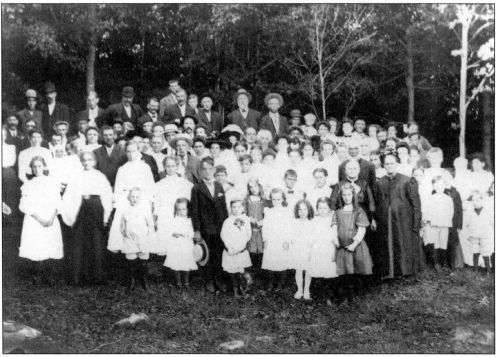

This photograph offers a formal shot deep in the Pittsburg woods.

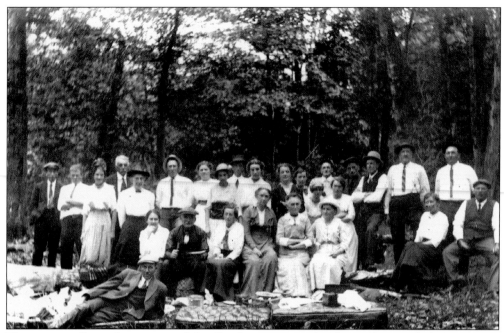

There is no telling what prompted this Pittsburg group to head into the woods for an outing, but one thing is for sure—it was dress shirts, ties, and hats for the men. A popular place for such a picnic was called Johnson Grove (where Murphy Dam is today). People from all over town would come to the grove for family picnics.

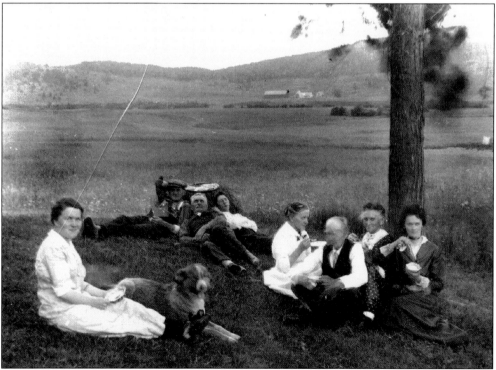

This group of Tabor Road neighbors chose their back pastureland for their lunchtime setting.

The waters of Pittsburg are abundant with well-stocked trout streams. A day's trip once offered the angler many tempting pools, from First and Second Lakes, Coon and Big Brooks as they tumbled down on their journey into the mighty Connecticut River. The inlets (East Inlet is shown here) to Second Lake were filled with trout, while Third Lake was, and is, a fascinating trip into the north, with a quaint Canadian village just beyond.

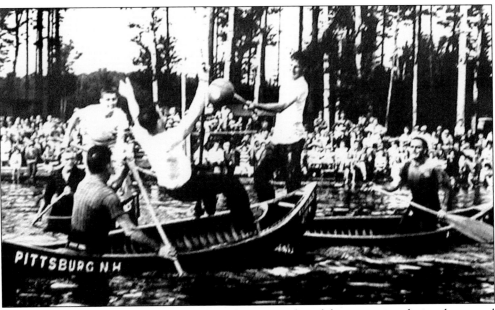

This photograph shows participants proving their strength and determination during the annual Pittsburg Guides Show demonstrations. The sportsman's show began in the 1930s, when it was part of the Izacc Walton League (a noted conservation organization). The annual event only recently ceased. Pittsburg boys, particularly the Covills, used to compete with other guides and sportsmen from other states. Winners often took home prizes for their canoe-tilting and woodchopping skills while the show promoted the Connecticut Lakes and forests.

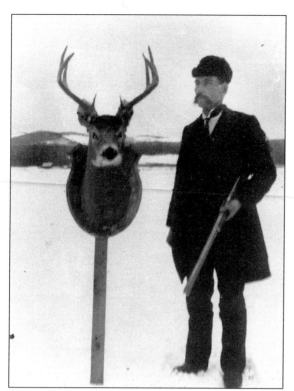

A prized deer head was mounted and preserved by this Pittsburg hunter.

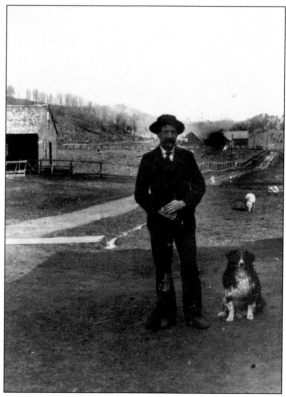

This photograph provides a formal shot of this man with his dog.

These men are dressed and ready for an excursion into the woods.

It looks as though Mr. Johnson is digging into a pan full of snow, likely smothered with hot maple syrup, at a sugaring-off party.

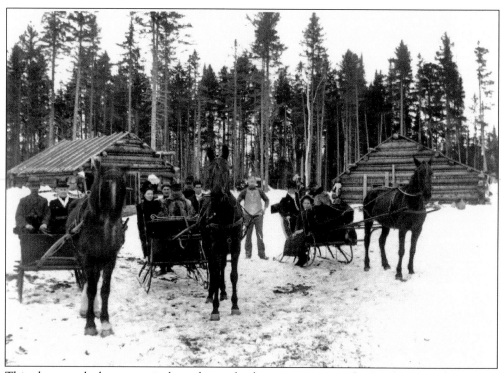

This photograph shows a typical one-horse sleigh at a campsite in the Pittsburg woods.

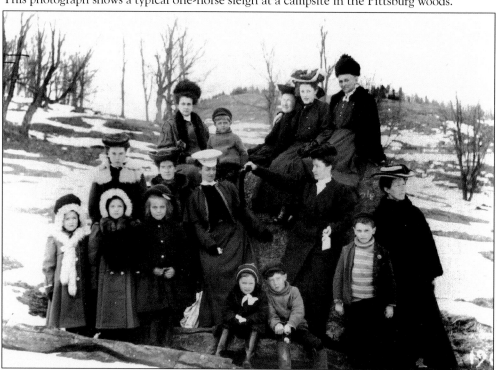

This large rock is still on this site even today. A sugarhouse used to sit near this rock, and there is a very good possibility these women and children were at a sugaring-off party.

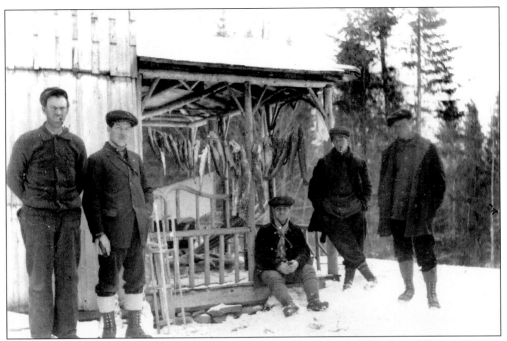

Ice fishing, another popular sport, very likely yielded quite a few fish for these fellows.

Among the many camps in Pittsburg was this one, Uneeda Camp. There was also Camp Tunkemall, which existed as early as 1895, and Camp Chester, which was built by Tom Chester in 1900. Tom Chester sold to a Mr. Gilman, who then sold to Alfred Stearns. Stearns then built the Far East Camps for boys, the original lodge of which was his private summer home. In 1947, that property was purchased by the Wilkinsons, who named it the Glen.

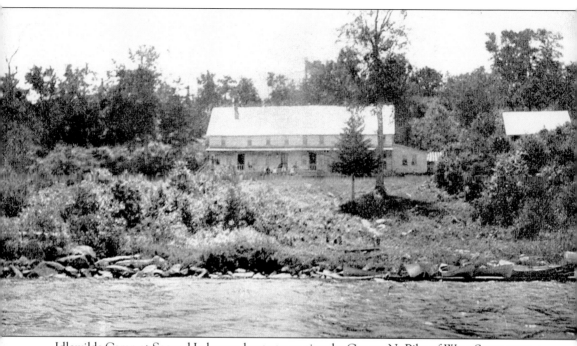

Idlewilde Camp at Second Lake was kept at one time by George N. Pike of West Stewartstown, who also owned Hotel Pike in that same town. There were accommodations for 50 guests at Idlewilde, which was a favorite resort for fishermen. At 2,000 feet above sea level, it was eight miles from the Canadian border and seven miles from Maine.

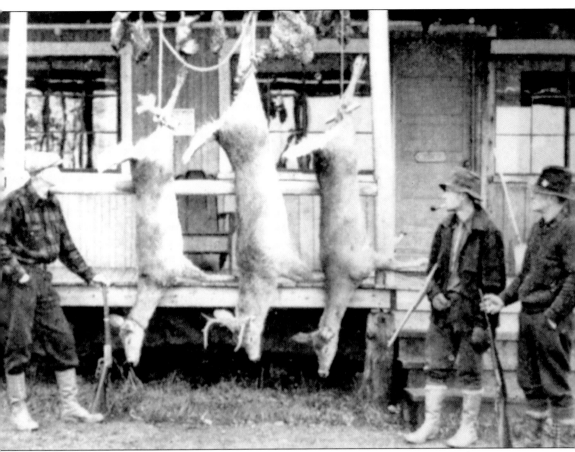

Three North Country guides look over some fine deer shot in the Connecticut Lakes region. (Photograph courtesy Northern New Hampshire Magazine.)

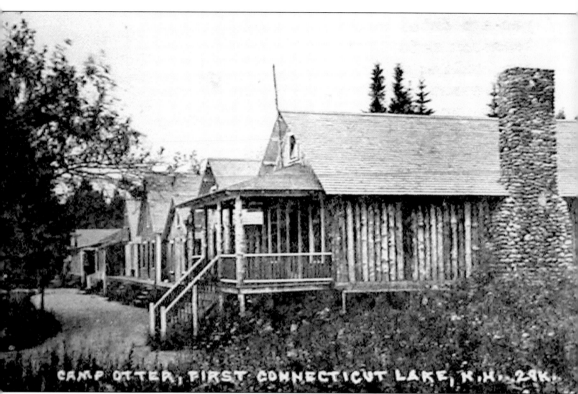

CAMP OTTER, FIRST CONNECTICUT LAKE, N.H. 29K.

Near where Reed's Hotel once stood is Camp Otter, which was built in the early 1920s by Frank Baldwin, who took over from his uncle George Baldwin and built additional cabins. In addition to the camps, area hotels included the Connecticut Lake House and Metallak Lodge. Another favorite stopover was the Half-Way House—named as such because it was located halfway between Canaan, Vermont, and the lakes area. After making extensive repairs to the Half-Way House and the adjoining dance hall, the new proprietor, Mr. Butterfield, held a grand-opening ball on Thursday, October 24, 1901. It was advertised that Mr. Butterfield spared no expense to make the ball the "event of the season."

This postcard bears a 1¢ George Washington stamp. It is from three gentlemen, Charlie, Dick, and Ricky, who noted that they "stayed here in Pittsburg last night. On our way to Conn. Lakes this A.M. Home Tonight. Write soon."

On October 25, 1922, this postcard was sent to a resident of Colebrook. It tells of how the writer was staying at Harry's and that they had just gotten home from a farm bureau meeting.

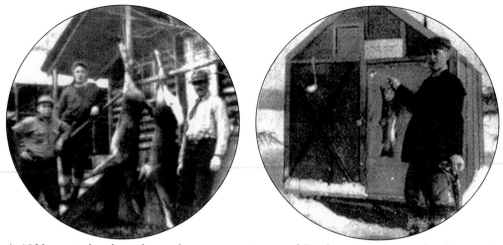

A 1930 tourist brochure featured numerous pictures of Pittsburg, since it was by then easily accessible for those with automobiles. "Good hunting at First Connecticut Lake, early Fall," is how this picture of men and their deer is described (left). "Come and try fishing through the ice," reads the inviting caption to this photograph in the 1930 tourist brochure (right).

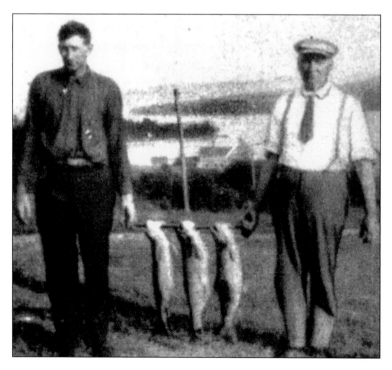

Another message to potential tourists: "Camp Otter's Fish Story, First Connecticut Lake."

Here, too, with the tag line "End of Path, Varney's Camps, First Connecticut Lake," tourists are enticed with the area's wilderness accommodations.

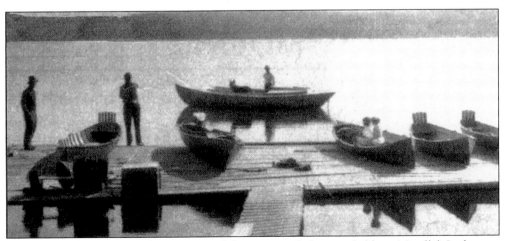

Shown here is the boat landing at Second Connecticut Lake—probably at Metallak Lodge.

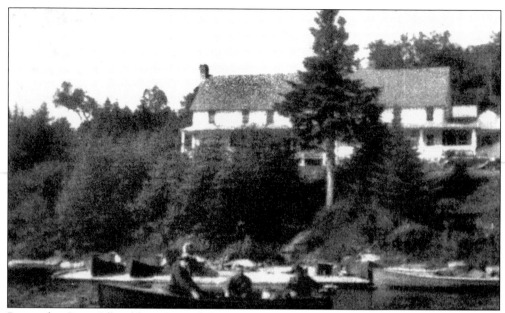

Pictured is Camp Idlewilde at Second Connecticut Lake.

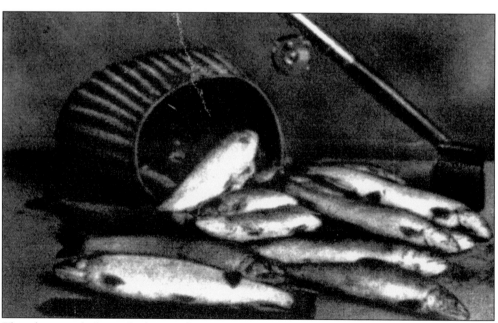

This photograph shows the bounty from a Connecticut Lakes fishing trip.

Seven

Bits and Pieces

These unusually shaped calendars were given to Frank Baldwin's customers in the dawning years of this century and were produced by the C.I. Hood Company of Lowell, Massachusetts. Probably no one distributed more calendars throughout the northern portion of Coos County than Frank Baldwin, proprietor of Baldwin's General Store. Baldwin carried a huge inventory that included everything from soup to nuts, and his assortment of calendars reflected just that. The 1905 calendar features Frank Baldwin's imprint for the E. Frank Coe fertilizer company, which was then celebrating its 50th year.

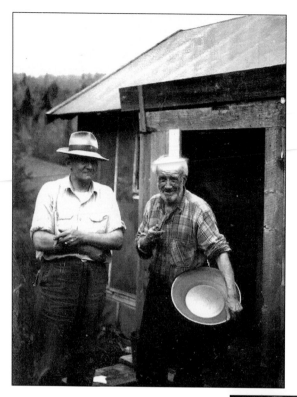

Cecil Davis (left) and Jimmy Frye are shown at the old Connecticut Valley Lumber Company depot camp on Indian Stream. At the time, Cecil was a turnkey at the county jail in West Stewartstown. Jimmy, then about 85 years old, was still panning and sluicing minute quantities of gold on the east branch in Pittsburg. Jimmy claimed to have served with Teddy Roosevelt's Rough Riders in Cuba in 1898 and that he participated in the famous charge up San Juan Hill.

The spirited Albert Lewis "Jigger" Johnson poses for a photograph taken by Robert S. Monahan. Monahan came to know legendary North Country woodsman Jigger Johnson in 1924 while working for the U.S. Forest Service. One legend Monahan related about Jigger was that in the early spring of 1910, when the Connecticut Valley Lumber Company was preparing to take logs down Indian Stream, Jigger sniffed the air and told river boss Alphonse Roby that there would be a "most damnable cloud-burst a week from next Tuesday." Jigger suggested that the head on the stream, used to regulate the flow for driving logs, should be strengthened. Sure enough, wrote Monahan, the heavens opened up that Tuesday, and torrents of rain came down onto the heavy snow that was still on the ground. The banks of Indian Stream gave out, and so did those dams.

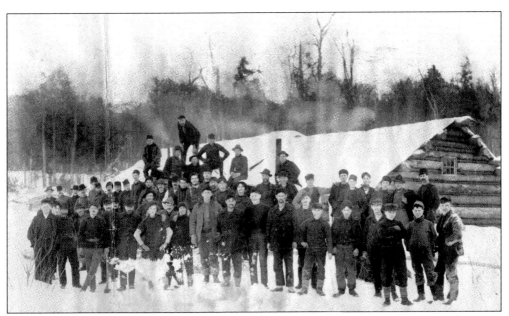

One of the Connecticut Valley Lumber Company camps in the north woods is pictured *c.* 1900. The company once owned 250,000 acres of land on the east side of Pittsburg that crossed over into Maine.

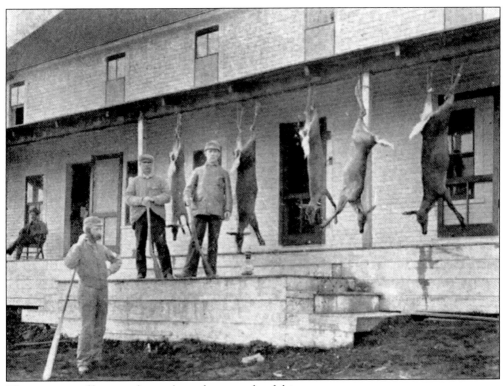

The treasures of hunting hang along the veranda of this camp.

Minik the Eskimo is buried in Indian Stream Cemetery in Pittsburg. Minik, his father, and four other Greenland Eskimos were brought to the American Museum of Natural History in New York in 1896 by Robert E. Peary, the well-known polar explorer. Four of the Eskimos died of tuberculosis. One adult was returned to Greenland alive. Minik, a boy of six or seven at the time, was sent to live with William Wallace, superintendent of the American Museum of Natural History in New York. Minik eventually returned to Greenland, although he was not restful, as he knew his family and friends' skeletons were on display in the museum. He returned to the United States in 1916 and signed on with an employment agency in Boston. His work led him to a lumber camp in Pittsburg. While in Pittsburg, Minik contracted the flu during the 1918 epidemic and died in the home of his friend Afton Hall in Clarksville. In 1993, the museum returned the four skeletons for a proper Eskimo burial in Greenland, close to the spot where they were born over a century ago. (Photograph by Charles Jordan.)

The *Boston Post* reported in 1939 that 1,500 automobiles filled both sides of the highway for two miles, with a crowd of 8,500 attending the dedication of the new international highway joining New Hampshire and Canada. Four New Hampshire state troopers, 6 Canadian mounties, 4 Frontiere men, 6 provincial police officers, and 16 customs and immigration officials were kept busy handling the traffic. Gov. Francis Murphy (for whom Pittsburg's Lake Francis was named) was on hand, along with J.A. Blanchette, Canada's federal member of Parliament.

During the long, cold winter months, New Hampshire's only customs office looks lonely and wind-swept, but do not be deceived. This customs checkpoint is tied into some high-level detection devices.

The Pittsburg Historical Society float is seen here during the town's 150th-anniversary celebration parade in 1990. (Photograph by Arlene Allin, Northern New Hampshire Magazine.)

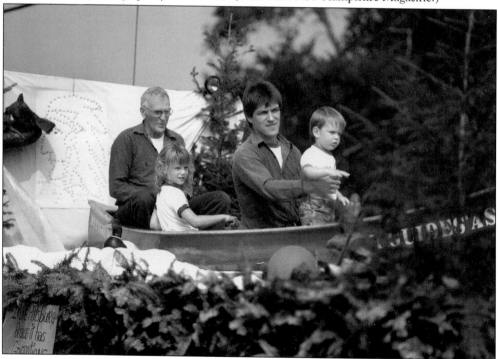

Members of the Covill family are seen participating in the town's 150th-anniversary parade with the Guides Association canoe. (Photograph by Arlene Allin, Northern New Hampshire Magazine.)

Doris Chappell, a former teacher, was known to clown around during many parades over the years, but she was especially pleased to take part in the town's 150th-anniversary celebration. (Photograph by Arlene Allin, Northern New Hampshire Magazine.)

Ernie Bunnell of Clarksville was often seen walking from his cabin in the Clarksville woods to the village of Pittsburg. Here, he rests in front of Moriah's Restaurant (formerly Baldwin's General Store) during the town's 150th anniversary in 1990. (Photograph by Arlene Allin, Northern New Hampshire Magazine.)

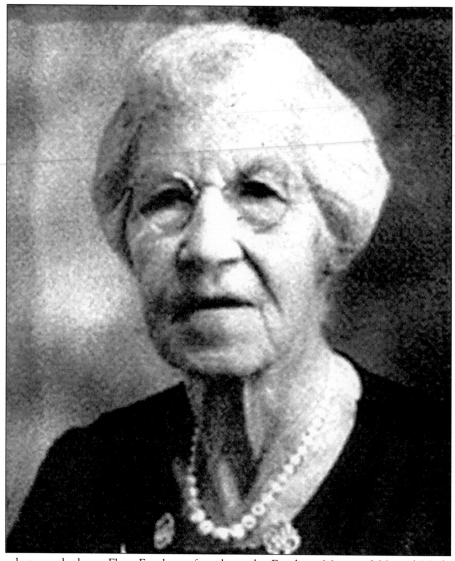

This photograph shows Flora Farnham, for whom the Farnham Memorial United Methodist Church in the town's village was named.

This old photograph shows the church before the entryway was added.

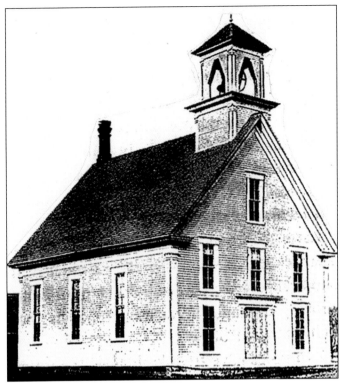

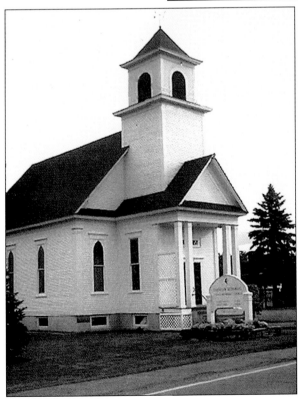

The Farnham Memorial United Methodist Church in the town's village has served its members since 1875. In 2000, it celebrated its 125th anniversary. (Photograph by Charles Jordan.)

At the Methodist church's anniversary in 2000 were these former ministers. From the left are Rev. Ralph Sabine, Rev. Margaret Bickford, Rev. Rodney Dobbs (the current minister), Rev. Oliver Northcott, Rev. D.S. Dharmapalan, and Rev. Curtis Smith. (Photograph by Donna Jordan.)

Five-year-old Taylor Ormsbee helps a choir member prepare hymn numbers for the Methodist church's 125th-anniversary service. (Photograph by Donna Jordan.)

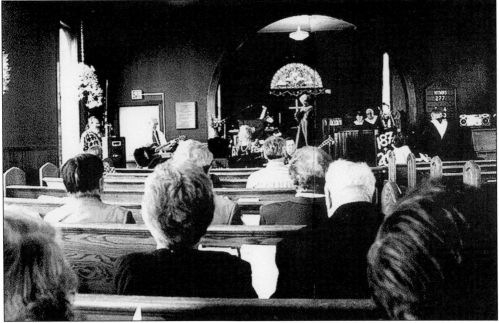

The interior of the Pittsburg Methodist church is shown during the 125th-anniversary service. Since 1875, it has had 46 pastors, with Rev. Ralph Sabine having the longest pastorate, from 1963 to 1976. Rev. Curtis Smith, who served from 1944 to 1952, was one of two pastors to be married in the church while also serving it. (Photograph by Donna Jordan.)

Taylor Ormsbee and her brother Matthew were candle lighters for the 125th-anniversary service of the Methodist church. (Photograph by Donna Jordan.)

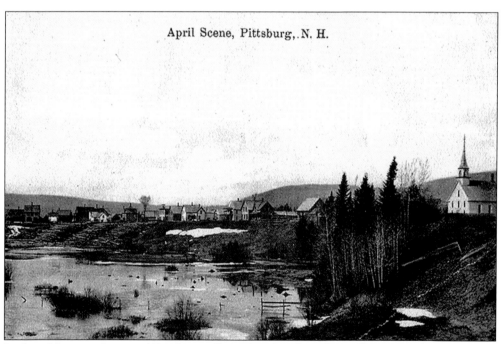

April Scene, Pittsburg, N. H.

In this old postcard view of Pittsburg village, the church and its tall spire can be seen at the right, while the Connecticut River, at the left, meanders south.

Eight

PITTSBURG'S MAN-MADE MIRACLE

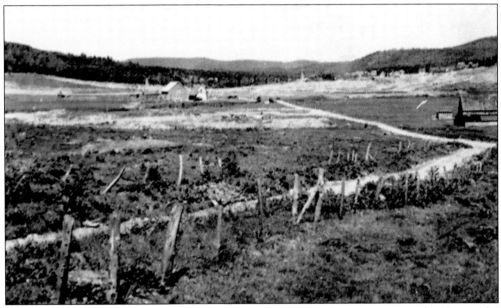

In the summer of 1939, Pittsburg was the scene of an incredible engineering undertaking—the building of a new dam. It seemed like a simple enough project, but to build this particular dam, workers transformed farmland, complete with homesteads and barns still on it, into a five-and-a-half-mile-long lake known as Lake Francis. This earthen structure was to be 2,200 feet long, 100 feet tall, and 580 feet wide at the base. From the dike, water was to travel underground, beneath a building, out into a concrete structure, and down into the Connecticut River. The ultimate purpose of this project—the largest public-works project undertaken in New Hampshire up until that time—was damming the Connecticut River and creating Lake Francis, named for Gov. Francis Murphy. It was initially built for water conservation and power production, although no power is actually generated at the dam in Pittsburg. The first power producer is at a small Public Service Company station downriver in Canaan, Vermont. This photograph is of the farmlands before they were submerged.

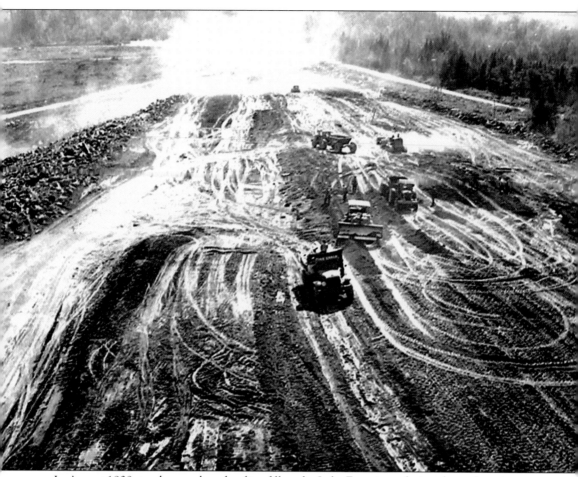

In August 1939, trucks were busy hauling fill to the Lake Francis work site, shown here in a view looking south from the gate tower. There is a misconception that the Civilian Conservation Corps (CCC) was employed to create Lake Francis, but that is not so. The CCC boys worked hard at creating an eight-mile stretch of road out of the wild North Country woods that would, by 1940, become an extension of Route 3—New Hampshire's first and only port of entry into Canada. An estimated 10,000 people were on hand for the dedication of that Daniel Webster Highway extension, with Governor Murphy on hand to do the honors.

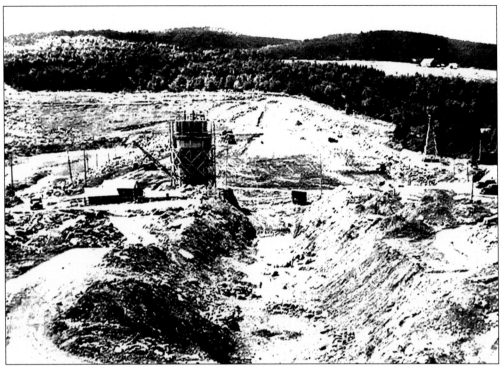

This photograph shows the gate tower under construction in August 1939.

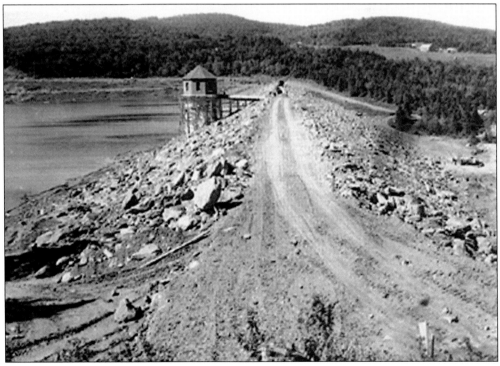

After nearly a year of construction, the gate tower is shown near completion in June 1940.

Engineers J.J. Baker, Lattanzi, and Richard Holmgren stand inside a 96-inch venturi tube used in the construction of the project.

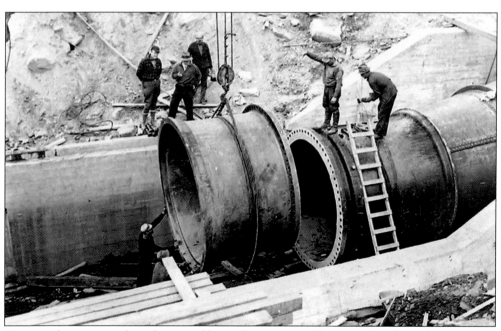

Venturi tubes increase the velocity and lower the pressure of the water that flows through them. Large sections of these tubes were put into place in September 1939.

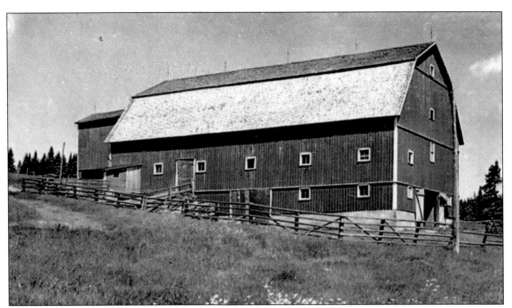
The Merrill Gray barn is shown as it looked in June 1939 on land that is now Lake Francis. Properties in the way of the planned reservoir were either sold and moved or burned down.

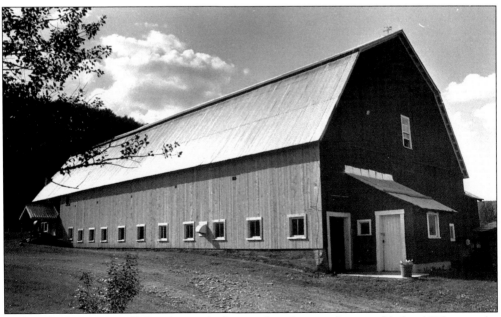
Today, the former Merrill Gray barn, which was taken down and reassembled in 1939, is on the Amey property on Tabor Road.

In this still from the 1962 film *The Manchurian Candidate*, Janet Leigh tells Frank Sinatra that she once spent a summer at a girls' camp at Lake Francis. Sinatra, who has just told her that he was from New Hampshire, remarks, "That's pretty far north."

Pittsburg's Lake Francis was immortalized into movie trivia with the 1962 release of *The Manchurian Candidate*.

Nine

CLARKSVILLE

The town of Clarksville, which borders Pittsburg to the south, was settled in 1832 by Benjamin Clark and at the time was known as the Dartmouth College Grant. When it was incorporated in 1853, the Dartmouth College Grant became Clarksville. Clark and two others had purchased 10,000 acres of land from the Dartmouth grant, while another 20,000 acres was purchased by two New York men. After failing to pay their taxes, the New Yorkers' land was sold to Gideon Tirrill and Josiah Young. Dating from 1876, the Bacon Road covered bridge connecting Clarksville and Pittsburg over the Connecticut River is the northernmost covered bridge over this river. This photograph appears to date between 1880 to 1900 and shows Clarksville, looking in the direction of Ben Young Hill. The back of this photograph reads, "The old Home Clarksville, N.H." The dirt path seen in this photograph has come to be known by many as the "mountain road," or Route 145. (Photograph courtesy Granvyl Hulse.)

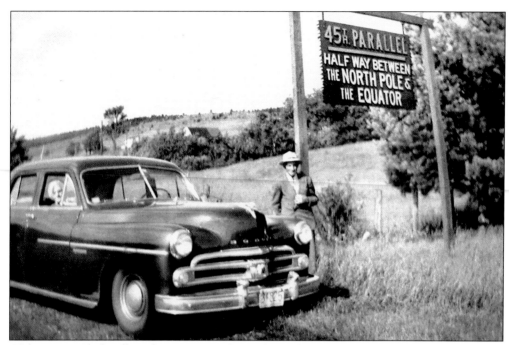

Welcome to Clarksville, a host town to the 45th parallel, the imaginary line that marks the halfway point between the equator and the North Pole. Mabel Young and Frank Perry are seen in 1953 next to the sign that was located in front of what is now the home of Elwin Ladd. The present-day sign is closer to the actual line, at the junction of Route 145 and West Road. (Photograph courtesy Beverly Uran.)

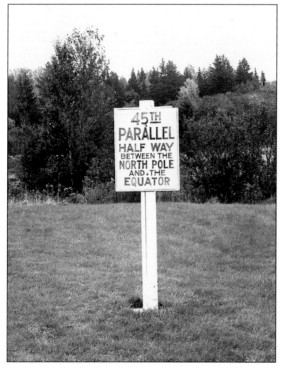

This 45th parallel sign marked the actual line and was brought to Clarksville in 1997. (Photograph by Charles Jordan.)

A crew from the New Hampshire Department of Transportation places the newest 45th parallel marker on Route 145 in 1998. (Photograph by Charles Jordan.)

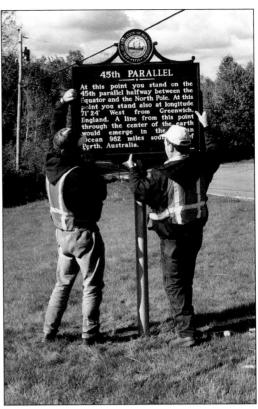

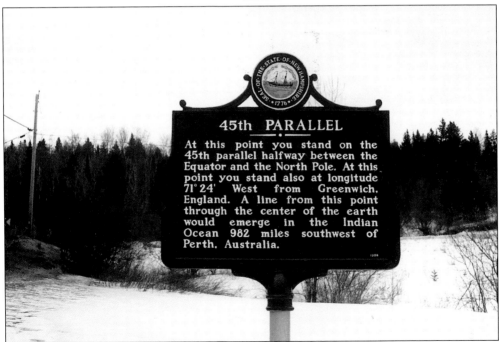

A closeup of the 45th parallel marker reveals the exact location on the opposite side of the earth from Clarksville. (Photograph by Charles Jordan.)

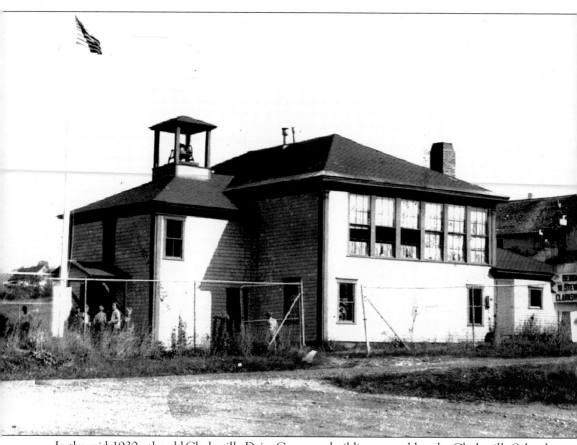

In the mid-1930s, the old Clarksville Dairy Company building was sold to the Clarksville School District, which turned it into a two-room schoolhouse for the town's student population. As a result, the town closed down several other school buildings in the process. The first floor of the new school was considered the basement, housing the two restrooms. The second floor featured two classrooms, with grades one through four on one side of the building and grades five through eight in the other. This photograph of the cheese-factory-turned-school was taken in the late 1930s. This is the oldest standing commercial building in Clarksville. Today, the building's first floor is home to the author and her family, and the second floor houses their publishing office for the *Colebrook Chronicle*, the *Lancaster Herald*, and *Northern New Hampshire Magazine*—the northernmost publications in the state.

In October 1943, the town of Clarksville gathered together to dedicate a 10-star service flag, marking each person from Clarksville who was, at that point, in the service during World War II. It was suspended between two poles across Route 145 near the Clarksville School. After the flag was dedicated, other Clarksville residents also went on to serve in World War II. (Photograph courtesy Earl Richards.)

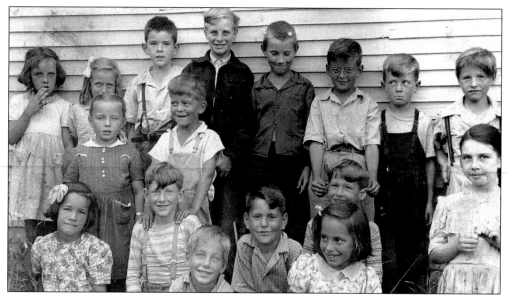

This late-1930s photograph shows a class from the Clarksville School.

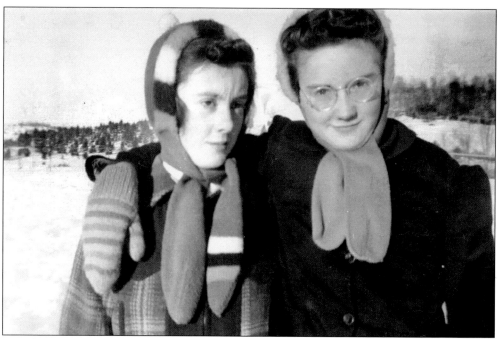

Friends Marjorie Keezer (left) and Madeline Paquette are pictured in 1939. The photograph was taken in front of the Clarksville School, looking down West Road. (Photograph courtesy Earl Richards.)

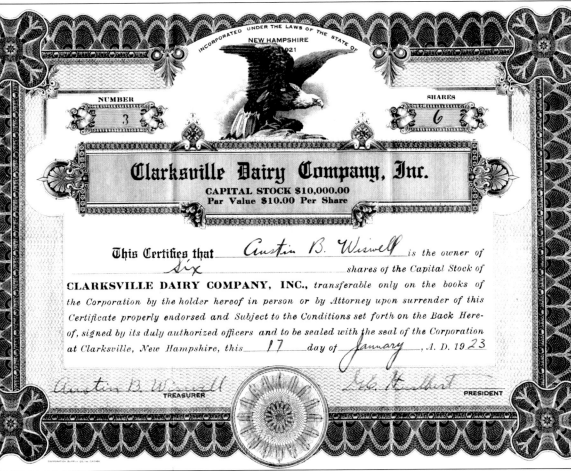

Shares in the Clarksville Dairy Company, which was incorporated in 1921, were offered for sale, with Austin Wiswell as the company's treasurer and Gerard E. Hurlbert as its president.

The other side of a Clarksville Dairy Company stock certificate shows that these shares were issued to Austin Wiswell in 1923.

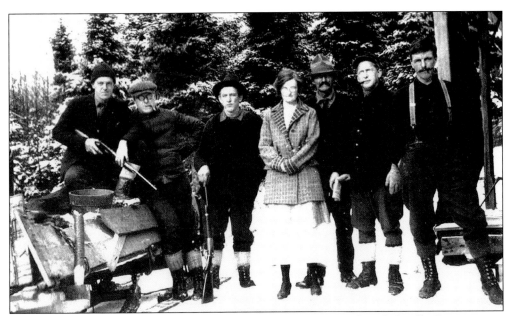

This photograph was taken at Carr's Camp in Stewartstown, near the Clarksville-Stewartstown town line. Daphne's parents, Celia and Harry Hurlbert, were good friends of the Richards family, and they all lived, at one time, on West Road in Clarksville. The woman in this photograph is Ardes Richards. Shown at the far right with the suspenders and mustache is her brother Willie Heath. (Photograph courtesy Daphne Hurlbert Godfrey.)

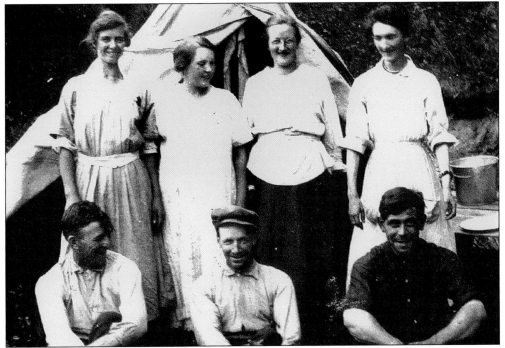

Dating from the early 1920s, this photograph shows, from left to right, the following: (front row) Harry Hurlbert, Walter Knapp, and Perley Richards; (back row) Hattie Knapp, Celia Hurlbert, Ardes Richards, and Myrtle Hurlbert. (Photograph courtesy Daphne Hurlbert Godfrey.)

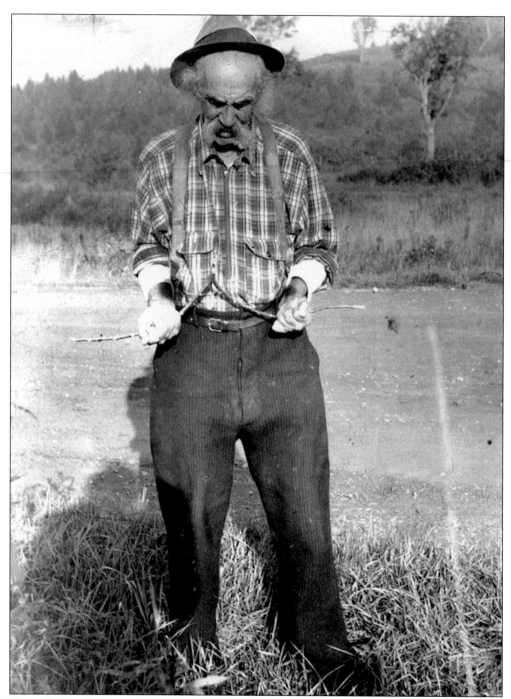

Quite the North Country character, Guy Kidder was a Paul Bunyan of a man with long hair and a handlebar mustache. Former Clarksville resident Wilman Furgerson said that Guy was six feet six inches tall and weighed 200 pounds. Guy lived on the Furgerson farm, and as a dowser he could always find water when he was asked to. When he died in 1955 at age 89, he was buried in the Kidder lot of the Stewartstown Hollow Cemetery, a few miles south of the Clarksville town line. His headstone reads, "Made Friends, Not Money."

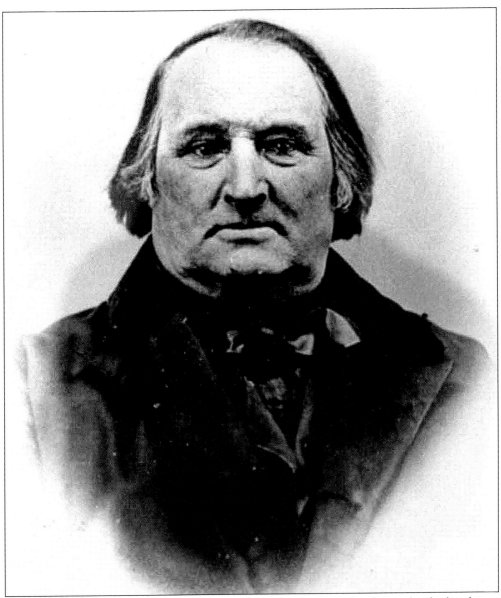

This tintype of Benjamin Young Jr. was found in the early-1800s farmhouse that he lived in at the foot of what would become Ben Young Hill. Born in Wolfeboro in 1799, Benjamin moved to Clarksville *c.* 1826, when his brother Josiah Young served as land agent for Dartmouth College. Benjamin built the farmhouse that still nestles at the foot of the hill that bears his name. He died on April 7, 1874, and is buried in the Young Cemetery a short distance south of his farmhouse.

This photograph of Ben Young Hill in Clarksville shows the twisting, turning contour as the road rolls south. (Photograph by Susan Zizza, Northern New Hampshire Magazine.)

Ben Young's homestead still sits at the foot of Ben Young Hill. It has been in the hands of Curtis Keezer, a descendant of Ben Young.

Ben Young is buried in the Young Cemetery, which sits alongside Route 145, leading up to his old home. His is the oldest birth date in the family plot, October 10, 1799.

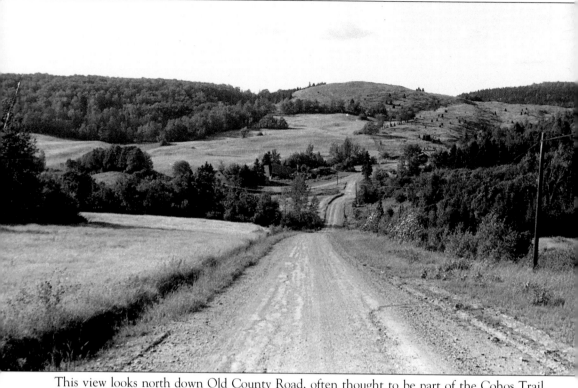

This view looks north down Old County Road, often thought to be part of the Cohos Trail. (Photograph by Charles Jordan.)

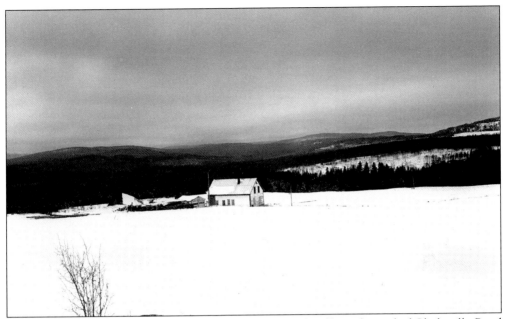

The old Raymond and Gladys Ricker farmhouse in Clarksville at the end of Clarksville Pond Road. The Rickers were the last of a line of families to live in the place. The road used to be called the Farmer's Road, reflecting all the farms that are now gone. (Photograph by Charles Jordan, Northern New Hampshire Magazine.)

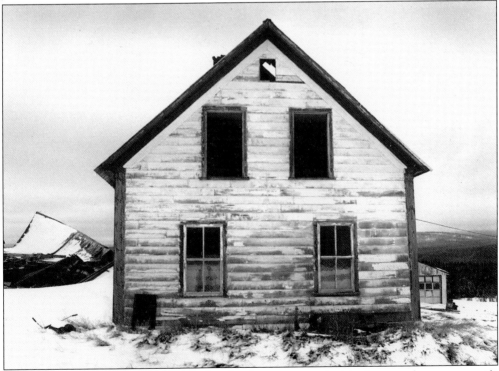

With all life gone from within, the Ricker farmhouse as seen in this photograph stares vacantly at empty fields. (Photograph by Charles Jordan, Northern New Hampshire Magazine.)

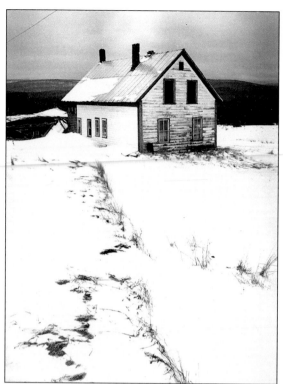

For a century, the old Ricker farmhouse sat at the end of a dirt road, watching over the seasons that would come and go. The home's final day came after the last snowstorm in April 1992. The owners of the property had decided the home was no longer useful to them and offered it to the Pittsburg Fire Department for a training session. (Photograph by Charles Jordan, Northern New Hampshire Magazine.)

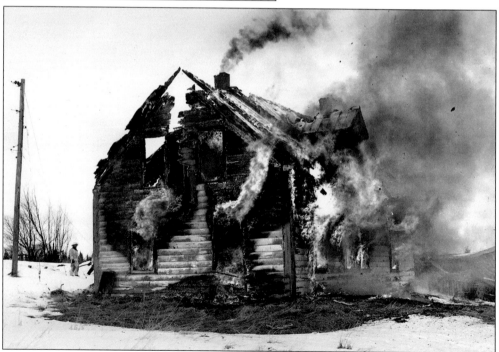

Within an hour after the local fire departments set the home ablaze, the house was fully engulfed—with the chimney belching out smoke for the last time. (Photograph by Charles Jordan, Northern New Hampshire Magazine.)

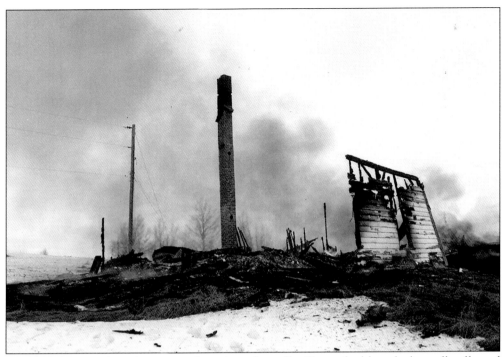

In a short time, only a chimney and portion of a wall still stood, although the wall collapsed moments later. (Photograph by Charles Jordan, Northern New Hampshire Magazine.)

Weather-beaten barn wood from the Ricker farm harkens back to the site's days as a working farm. (Photograph by Charles Jordan, Northern New Hampshire Magazine.)

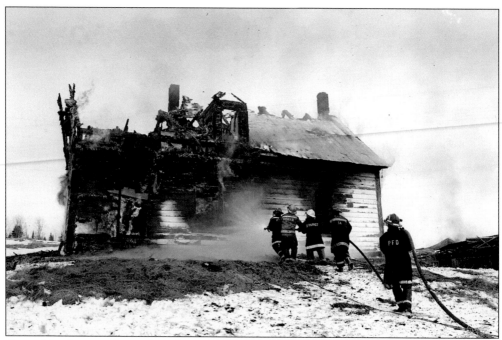

A combined crew of members from the Colebrook, Pittsburg, and Beecher Falls, Vermont fire departments staged a practice attack on the half-gone Ricker home. (Photograph by Charles Jordan, Northern New Hampshire Magazine.)

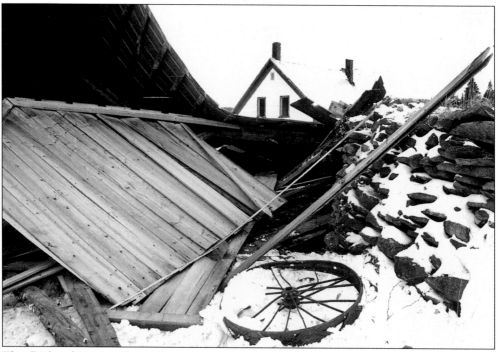

The Ricker house peeks out over the remnants of the barn, which had been razed in anticipation of the big burn on the home. (Photograph by Charles Jordan, Northern New Hampshire Magazine.)

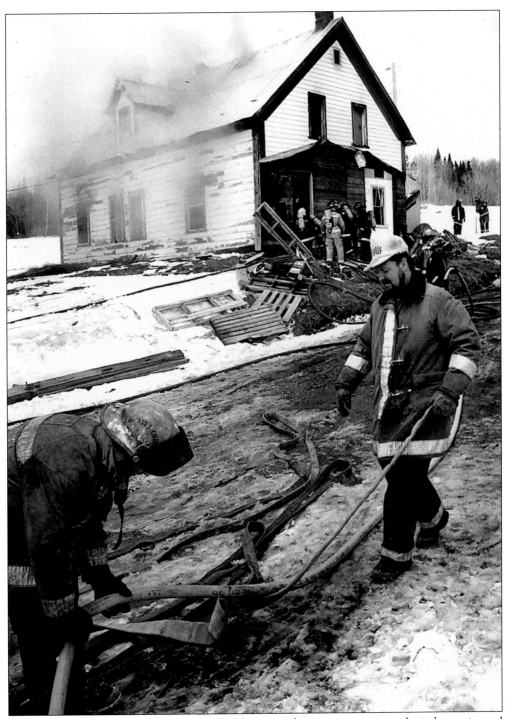

For the first couple hours of the controlled burn, smoke sessions were conducted upstairs and then on the first floor. Firefighters are shown in this photograph running hoses to the house. (Photograph by Charles Jordan, Northern New Hampshire Magazine.)

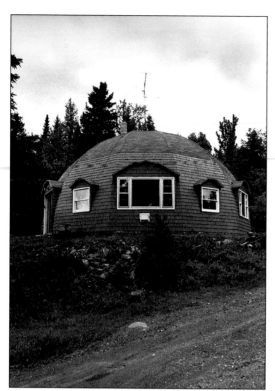

What started out as a tool shop evolved into a home for Donald and Evelyn McKinnon of Clarksville. Their dome house on a Wiswell Road was designed by Mr. McKinnon because he did not want to pay the high price for a dome house kit. (Photograph by Charles Jordan, Northern New Hampshire Magazine.)

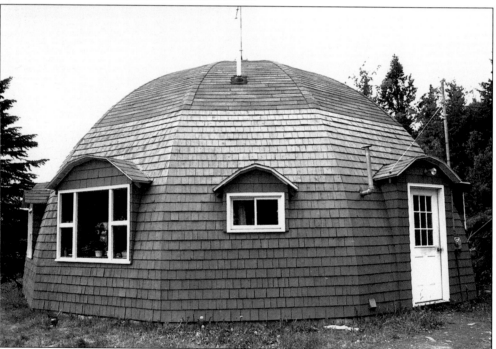

Evelyn McKinnon once said that living in a round house never caused them any problems, though one winter, a passerby wanted to know what was under "that huge mound of snow." (Photograph by Charles Jordan, Northern New Hampshire Magazine.)

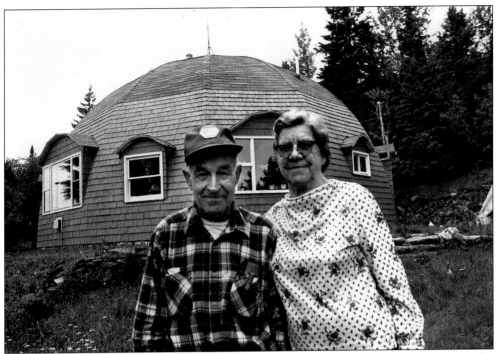

Donald and Evelyn McKinnon of Clarksville built their dome house in 1983. (Photograph by Charles Jordan, Northern New Hampshire Magazine.)

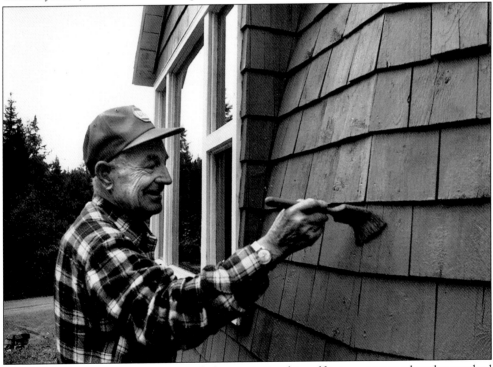

Donald McKinnon was not concerned about painting himself into a corner when he touched up his dome house. (Photograph by Charles Jordan, Northern New Hampshire Magazine.)

The heaviest snows often come to Clarksville in the month of January. With an elevation of 1,977 feet above sea level, the old Clarksville schoolhouse stands bright white after a fresh, heavy snowfall. (Photograph by Charles Jordan, Northern New Hampshire Magazine.)

This photograph shows a Clarksville Wiswell Road home after a fresh January snowfall. (Photograph by Charles Jordan, Northern New Hampshire Magazine.)

In this view, Route 145 unwinds north like a roller coaster toward Ben Young Hill. (Photograph by Charles Jordan, Northern New Hampshire Magazine.)

A photograph features snow-laden branches on a road in Clarksville. (Photograph by Charles Jordan, Northern New Hampshire Magazine.)

What appear to be marching snowmen are actually snow-encased trees in Clarksville. (Photograph by Charles Jordan, Northern New Hampshire Magazine.)

The Clarksville Town Hall is set amid a pristine winter landscape. (Photograph by Charles Jordan, Northern New Hampshire Magazine.)

Snow caps the headstones at the Young Cemetery on Route 145. (Photograph by Charles Jordan, Northern New Hampshire Magazine.)

This photograph shows the view when looking back toward Ben Young Hill—approximately 2,500 feet above sea level. (Photograph by Charles Jordan, Northern New Hampshire Magazine.)

The driveway shown in this photograph turns off the very top of Ben Young Hill. (Photograph by Charles Jordan, Northern New Hampshire Magazine.)

Regardless of the season, it is best to heed the sign's Use Low Gear warning when descending either side of Ben Young Hill. The effect is only heightened in the winter, when many a car and plow has found itself off the road. (Photograph by Charles Jordan, Northern New Hampshire Magazine.)

As this photograph documents, snow-covered brush in the foreground makes for fantastic wintertime forms. (Photograph by Charles Jordan, Northern New Hampshire Magazine.)

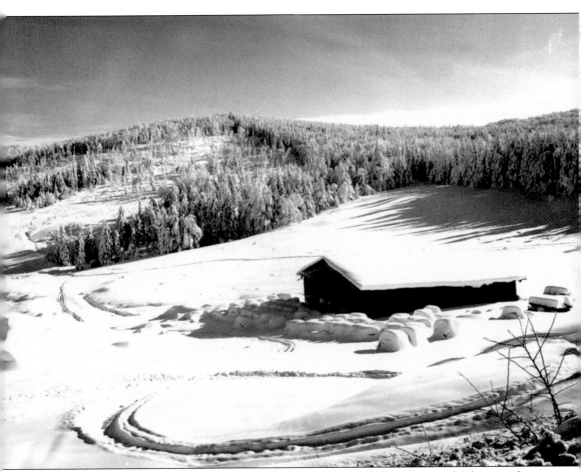

This old barn on a Clarksville farm seems to hold a good amount of snow on its roof. (Photograph by Charles Jordan, Northern New Hampshire Magazine.)

Laughing Water Family Cottage adopted a portion of Route 145 to keep it clear of roadside litter. Their sign appears after the ice storm of 1998 with icicles hanging from the bottom. (Photograph by Charles Jordan, Northern New Hampshire Magazine.)

An ice-laden branch is suspended on wires over Ben Young Hill in the wake of the 1998 ice storm. (Photograph by Charles Jordan, Northern New Hampshire Magazine.)

This closeup of tree branches shows the handiwork of the ice storm. (Photograph by Charles Jordan, Northern New Hampshire Magazine.)

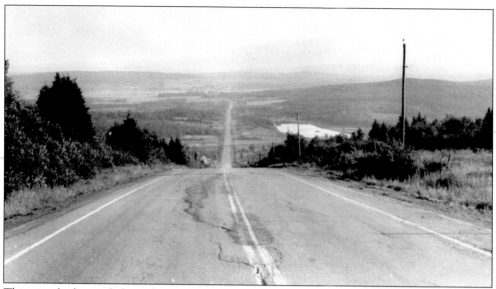

This view looks north from the Pittsburg-Canada line into Chartierville, Quebec. (Photograph by Charles Jordan.)

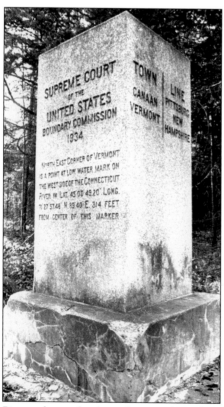

Pictured are the boundary markers for the Pittsburg-Vermont-Canada line (left) and the Pittsburg-Canada line. (Photographs by Charles Jordan.)